Paint Watercolour

CAPTURING THE MOMENT

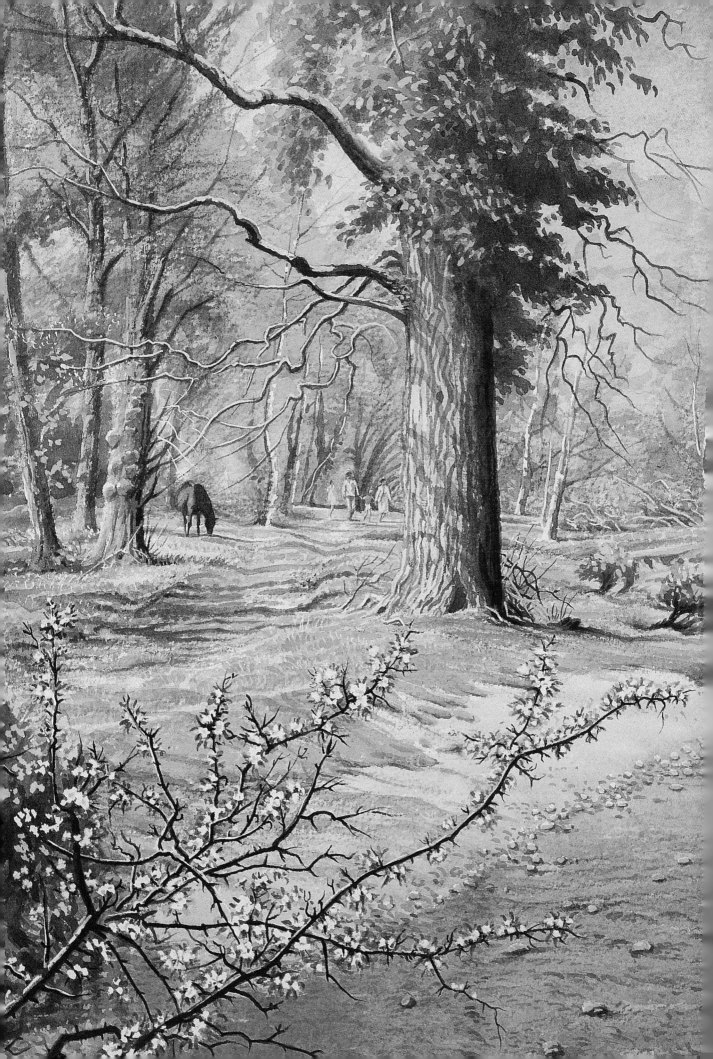

Paint Watercolour

CAPTURING THE MOMENT

WILFRED BALL

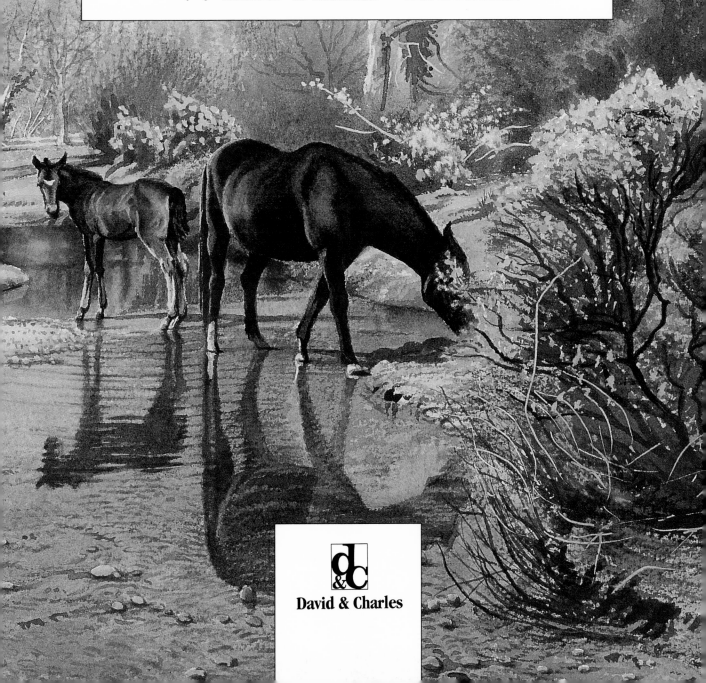

David & Charles

To Sue, Ralph, Matthew and Rachel with love.

(Previous pages)
Sunday morning in spring, New Forest 22 × 15in (56 × 38cm)
How archetypal can you get? The location was one of the many 'Bottoms' in the northern part of the New Forest. All around, the May sunshine glinted on twigs and blackthorn blossom, the soft green haze of April's buds was heralding May's full foliage, the air was rich with the smoky redolence of gorse blossom, and the shallow stream chuckled along between the pebbled shallows. On top of all this the tall trees stood among banks of bluebells. The chatter of excited children filled the air. And as if this were not enough, everywhere were the famous New Forest ponies followed by foals which were irresistible to the children. Is there any wonder I rushed to paint this cornucopia of magic moments!

But it is this embarrassment of riches which places a question mark against the painting. While I have succeeded in my main aim – to display the freshness, sparkle and soft colour that is the gaiety of springtime – the composition of the picture has suffered. After drawing the preliminary details on the paper I suddenly realized that I hadn't included any blackthorn. This, the whitest of all blossom, would be a sad loss to the overall sparkling quality so I decided to put in the branch in the foreground. It was intended to be a finger pointing into the picture but by extending it I only succeeded in placing a barrier between the eye and the focus of the composition. Delicate though this barrier may be, it is clearly an error of composition, an essential element that is always more important than detail. Ah well, I don't claim to be perfect.

In spite of the gay colours I did not use a large palette. In addition to my normal, simple range of cobalt blue, yellow ochre, burnt sienna, burnt umber, alizarin crimson and winsor green, I added cadmium yellow for the bright yellows of the gorse blossoms and ultramarine blue for some of the strong darks. For example the horse was painted initially with burnt umber, and then the really dominant dark tones were overpainted with a mixture of alizarin crimson and ultramarine.

Bright colours show up best if backed by a variety of subdued, neutral tints. As here, the result should be lively but not gaudy.

Acknowledgement
Colour photography by John Colley, Darley Abbey, Derby except for the photographs of the Demonstration paintings, which were taken by the author.

A DAVID & CHARLES BOOK
Copyright © Wilfred Ball 1994
First published 1994

Wilfred Ball has asserted his right to be identified as author of this work in accordance with the Copyright, Designs and Patents Act 1988.

A catalogue record for this book is available from the British Library.

ISBN 0 7153 0103 9

Typeset by ICON, Exeter
and printed in Hong Kong by Wing King Tong Co., Ltd
for David & Charles
Brunel House Newton Abbot Devon

CONTENTS

INTRODUCTION

Yesterday I walked into the woods and the bluebells were out. What a prosaic way to describe a miracle. The bluebells were out – cascading down the slope into the stream below. Sunlight filtering through the canopy dappled the tree trunks. The swathes of flowers were stained with ultramarine in the shadows and warm lilac in the light. For a landscape painter such magical moments are particularly potent. A sketch or photograph will record them, for he will undoubtedly want to make use of the experience. Normally we see the landscape in unremarkable circumstances. We have to learn to cash in on those rare moments when something special happens. They are the elements that will make our paintings special – with a little luck.

Equally treasured is a bright Sunday morning which I recall from my distant childhood. It was after chapel of course, and there had been a severe frost. The hedgerows and ditches which the previous week had been a tangle of overgrown weeds and debris, unkempt and desolate, had become an enchanted fairyland, every dead leaf and twig sparkling in the sun. The dark, dank weeds in the ditch were encrusted with white diamonds while their pendant cobwebs had thickened into chains which corruscated in the light. Perhaps my memory of this boyhood stroll would have faded a little by now but for being reinforced by other frosty forays over the years since. But the magic will always stay fresh in my mind.

Highlights, so apt a word, of our visual experiences are invariably to do with some manifestation of light. Countless expeditions flood my mind with pleasant recollections of just such rewards. Walking round Buttermere once when it was shrouded in thick mist, its sheltering fells lost to view, the morning was saved by the slow, creamy sun struggling painfully into view, faintly gilding the tips of the autumnal birches. Gradually, as the glow became widespread the whole of the surface at the far end of the lake silvered and shone. The Lakes have provided me with a host of such memories.

You will be unlikely to produce a noble landscape painting if you have not taken to heart such

moments of supreme nobility. They will not only provide subjects for immediate use – for these are the ones I cannot wait to tackle – but they will nourish your potential for transforming an unremarkable future subject into something better.

It is from such stimuli that the painter finds his inspiration. In other artistic fields – poetry, drama, music – the inspiration takes the form of an idea that carries the mind in a new creative direction. In the case of the visual arts this is rare. Painters and sculptors are excited by the look and feel of things. Ideas tend to follow a visual stimulus rather than the other way round. We see something interesting or even wonderful and we can't wait to paint it, to capture on paper the excitement we've felt. The winter dawn that 'comes up like thunder'; the sudden sunburst filling a valley that only seconds before was shrouded in mist; snow sprinkling a mountain like the icing on a cake; a haze of bluebells

in sudden spring sunshine; a blizzard of seagulls wheeling in the wake of the plough.

The purpose of this book is to show the particular landscapes that have inspired me and to demonstrate the various techniques I have used to paint them. I hope this will enable my readers to solve their own painting problems and to have the courage to tackle even the most demanding of subjects. Such a prospect at first may appear daunting but I hope to show you that it need not be so. Frequently the magical qualities of the medium itself will work the miracle for you. No medium is so full of the 'happy accident' as watercolour. It is a marvellous medium for painting seductively subtle effects such as skies, water, mist and other diffuse phenomena. Being evocative is second nature to watercolour, in which magic and mystery march hand in hand.

Coming to the paintings, which make up the body of the book, I propose to describe briefly how and where I saw each of the subjects, as well as commenting on my immediate emotional and intellectual reactions to it. I shall describe in considerable detail the process of painting many of the pictures. In other cases, however, where this might prove to be repetitive, I shall concentrate on briefer descriptions of individual effects.

I do not paint on the spot. As you can see, my paintings are fairly complex in composition and it would be impossible for me to produce work that I would consider to be of exhibition standard if I did not paint in the studio. My normal procedure is to produce sketches or photographic material out of doors which I can then use to put together considered compositions in the studio. Those who have read my book *Sketching for Landscapes* will know that I used to work entirely from sketches. As I get older, however, I find it more and more arduous to sketch in relatively bleak moorland country in doubtful weather and I produce most of my material these days with the aid of the camera.

In the design process I will use more than one source – several sketches and/or photographs combined – to develop my initial pencil drawing. At this stage I will introduce animals and human figures wherever I think it necessary for local colour and to emphasize a sense of place. It is extremely important to give ample thought to these design procedures, so that one can begin the painting full of confidence that all problems have been anticipated. This is the only way to achieve the sense of freedom that painting in watercolour requires. Because of the fine detail and texture I use in my foregrounds I usually need then to make use of masking medium (frisket), which is another important aid towards this feeling of freedom. Only then do I begin to paint.

MATERIALS

Brushes, paper, paints, pencils and water are the only materials essential to the traditional watercolourist. To this I personally would add masking medium (frisket) and a drawing pen.

Brushes

Do not buy cheap brushes. They quickly lose their points and shape and represent a false economy. Always clean brushes thoroughly after use. This will prove a *real* economy, preserving them in good shape for much longer.

Choice of brushes is obviously individual. A *trompe-l'œil* painter or a painter of flora and fauna will need lots of fine brushes because of the delicate and precise nature of the subject matter. The landscape painter will not need these. My smallest brush is a No. 2, which I use for thin twigs and fine detail. The rest of my sables are No. 4, No. 6 and No. 10, together with about half a dozen large wash brushes. My largest brush is a 1½in (4cm) chisel-ended pastry brush which I purloined from my wife many years ago. As I paint a lot of full Imperial paintings it is invaluable for the skies and because of its pointed corners it is quite capable of delicate manoeuvres when faced with complex shapes.

Paper

Watercolour paper is made in three surface textures: Smooth or 'Hot-pressed'; Not, which is somewhat rougher, and Rough, which has a pitted surface and accommodates a bolder style than the others. It is excellent for drybrush work, for example to simulate light sparkling on choppy water. It also emphasizes the granulated wash, so that when using colours which leave a powdery deposit in the hollows one can produce a textured surface without any effort. I use both Fabriano Rough, which has a biscuit-like texture, and Arches Rough, which is rather more regular – more often the latter because it seems to suit my style.

Paper is graded by weight per ream. Anything under 300lb (136kg) will need stretching before use, as it buckles when thoroughly wet. For this reason, being lazy, I only use 300lb weight.

Paints

Don't waste money buying sets of paints – you'll never use half the contents. All you need is a smallish container, such as an old cigar box, to keep your paint tubes and brushes in when you are carrying them about. Buy only the colours you know you need: you can always add to them later. I'll give you my own range of pigments in a moment to act as a guide. Don't use pans: they dry up quickly and ruin your brushes. Always buy artists' quality tubes, which will guarantee colours that are permanent, don't fade, and will stay moist and fresh to the end. For mixing trays I use the white plastic containers so popular in children's play groups and nurseries.

Palette

My palette is relatively limited. I have painted dozens of paintings with no more than cobalt blue, yellow ochre and burnt sienna, particularly subdued, misty subjects. To these three, however, I add burnt umber, alizarin crimson and winsor green. Those six colours are normally quite adequate for my needs.

For brighter colours, when painting flowers for example, I will add cadmium yellow and cadmium red. Mixed together these will produce a really bright orange. If I need a wider range of earth colours, as for some autumnal subjects – dead leaves for instance – I have raw umber and raw sienna available.

Where strong tonal contrasts are necessary I have two favourite mixtures which are really powerful. The first, alizarin crimson and ultramarine blue, will produce a range from midnight blue to deep purple. Applied on top of a brown wash it will create the most intense black. The second, alizarin crimson and sap green, will give a range of brownish greens which are ideal when painting such features as the darks under clumps of heather.

Do not use black·or white. The former will kill stone dead any other colour you mix with it, whereas the dark mixtures I've described above produce a luminous effect with which black cannot compete. As for white, this is supplied by your paper. It will glow through any pale wash you put on, to create all the tints you could possibly need. If left untouched the paper will outdo any white pigment you could apply. Nor do you need it to mix a grey: cobalt blue will mix with varied amounts of burnt sienna to produce a wide range of greys. You can use ultramarine with the sienna if you need a really dark grey, but I can't imagine that you would ever need any other colours for this purpose.

For beginners, green is the most dangerous colour in landscape painting. Never use a green straight from the tube. Always add some other colour to produce a more subdued natural tint. For a bright spring green I would mix yellow ochre with my winsor green. For any other natural green I always add a touch of brown or even red to subdue it somewhat. This will prevent your greens from looking gaudy.

THE PROCESS OF PAINTING

Painting, the sheer physical process of it, is really not a difficult business, and it can be tackled with confidence. I can describe the whole thing in a very few sentences. You will need a minimum of three brushes – a large wash brush, a medium-sized one, between size 8 and size 6, and a small one, say a No. 2.

Always mix plenty of paint before beginning, then start to paint on a piece of paper which is dry, moist or wet, according to the type of subject. I damp my paper with clean water using a large brush or a sponge. If I want it really wet I hold it under the tap, then hold it vertically to drain off the surplus. The actual painting is completed in a few basic procedures. After all it is simply a matter of making coloured marks on the surface of the paper. To begin with the marks will be broad patches of relatively pale colours which we call washes. These washes will get progressively smaller until we have covered the paper except for a few untouched areas which have been left, either by design or accident. The more white paper you leave the lighter and sunnier will be the appearance of the final painting. When these washes have dried we make further marks of progressively smaller and stronger colour until the painting is complete. The final marks will be dots and lines for the finer detail.

The marks you make will be peculiar to you. The simpler the better. Aim first of all to be satisfied with simple wash drawings without much detail. It is in those first washes that the magic of watercolour resides and this can make even the simplest sketch appealing. As you progress you will find a few problems that you can't solve just by practice. The best solution is to join a sketching club where you can talk to others who have faced the same problems. Above all go to lots of exhibitions of artists whose work appeals to you. Examine the way they paint. Absorb any idea or technique that is of use to you. No trick is the moral or legal possession of any single painter. All of us have developed a technique based upon our own individual ability but enhanced by processes we've had the good sense to acquire from artists we admire. Talk to as many good practitioners as possible. I get literally dozens of would-be painters coming up to me during my exhibitions and I'm only too delighted to pass on any tips I can. Eventually, on one of the happiest days of your life, someone will come to you to tell you they can recognize your work without looking at your signature. This is a clear sign that you have achieved your own style and may be on your way to becoming a professional painter.

1

A CHANGE OF LIGHT

I suppose the main reason why inspirational experiences are so telling is that they are usually archetypal, common to everyone's experience and part of the fund of human nostalgia we can all dip into. Everyone remembers picking bluebells as a child. A fine sunset cannot fail to catch every eye. One of the reasons why my favourite sketching weather is 'sunshine and showers' is the moment when the sun breaks through the clouds to sparkle on shiny leaves and gleaming, silvered surfaces. Sun on snow is most magical.

To the landscape painter the sun rules over all. It provides our light. The layers of atmosphere between the sun and the earth give us our weather. When it breaks through the cloud, even for a moment, some hitherto undistinguished landscape feature may be selected for a few seconds of glory. The mood and atmosphere of our subject matter is completely dependent on the quality of light, whose changes are a constant source of fascination.

My first group of paintings will attempt to illustrate this fascination, which is at the heart of most of the moments of visual inspiration to which my memory clings (often with the aid of the camera). As a professional painter I depend on such memories constantly, using them to help transform a drab subject into something more appealing. I'm talking about those 'if only' subjects we're all familiar with. You know the ones. If only the sun would come out. If only the light were gilding that particular tree. If only it had rained to fill those deep ruts in the lane. If only it were autumn. How different this would look if only it were blanketed in snow. I could go on for ever. A catalogue of frustration. When I began to paint professionally I decided I couldn't afford to allow potentially interesting subjects to be lost because I was seeing them in poor light or weather. So I have developed a technique which I call 'transformation'. I dredge back in my memory for some effect of light, mood or atmosphere I've seen somewhere else, perhaps years ago, and with it I embellish the disappointing subject in order to transform it into a swan. Of course, if it is possible to go back to the subject in more ideal conditions, I will, but it is not always convenient. So then I must imagine that effect of light or weather from my past experience which will best transform my ugly duckling of a subject – imagination in the service of art.

Most of the pictures in this book are the direct result of seeing something that was an immediate inspiration, but some transformations are included, as I will point out when they occur. However, even in poor light it is possible to overcome the conditions. The main victim here is tonal contrast, and the solution is to find subjects which already contain strong darks and naturally light surfaces, as you will see in 'November Morning in Dovedale' (page 12).

▷ *Rainbow over Fairbrook Valley, Kinder Scout*
11 × 15in (28 × 38cm)
Coming down off Kinder Scout one sunshine and showery day this scene suddenly confronted me. From the autumn colours in the foreground, richly enshadowed, the rainbow cast a great swathe of golden light across the foot of the valley, burnishing the top of a single tree which glowed against the cool face of Bleaklow. It was a most dramatic effect, as you can see and it would be hard to imagine a more seductive juxtaposition than this rich darkness against the blaze beyond. And not forgetting the rainbow.

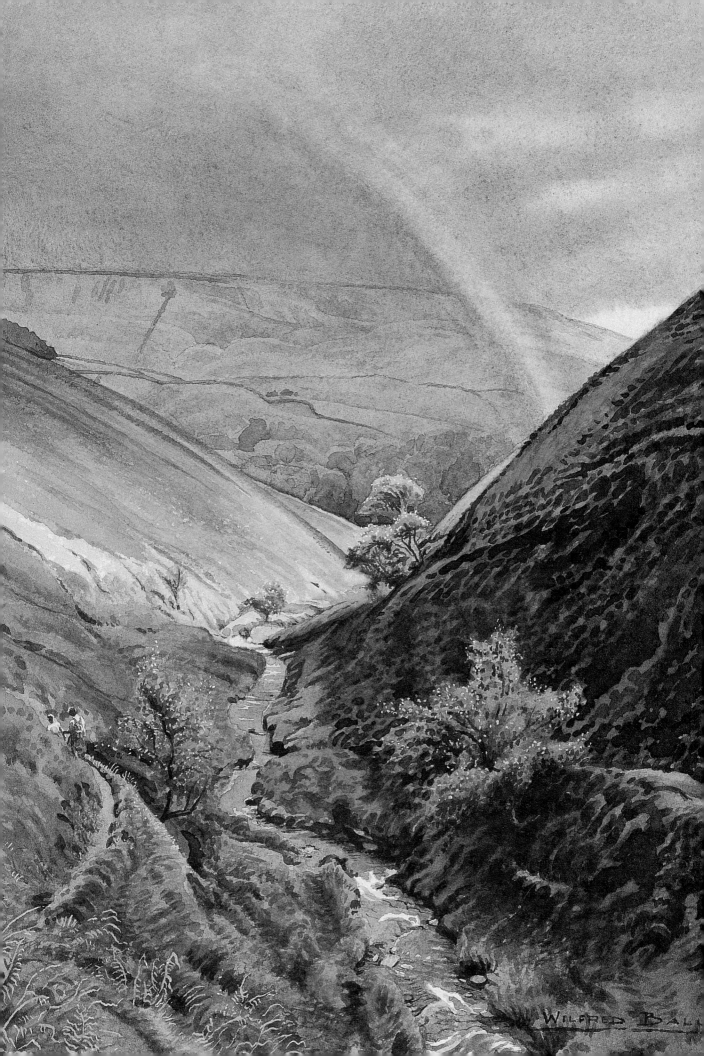

WILFRED BAL

POOR LIGHT – TONAL BOREDOM VERSUS ATMOSPHERIC POTENTIAL

As a professional painter I sometimes need to produce paintings under pressure of time, usually because I have an exhibition coming up and not enough paintings to fill it. One cannot wait for inspirational subjects and may have to make the most of a spell of dull weather by using a little ingenuity. In these circumstances I tend to use my technique of 'transformation' to improve my subjects. However, if you go out properly prepared mentally you can find satisfactory subject matter even in unpromising conditions, as on this next occasion.

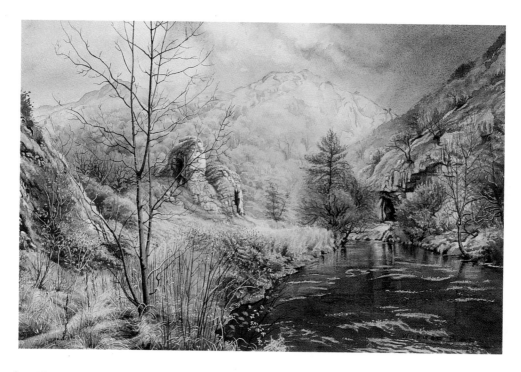

△ *November Morning in Dovedale 22 × 15in (56 × 38cm)*

For the whole day we saw no sign of the sun so we had the worst possible light. If it had been misty or foggy at least it would have offered a poetic or mysterious atmosphere. The drab light reduced tonal contrast and as we walked through the dale we feared we were going to have a wasted day. But I refuse to believe that this is possible in Dovedale and anyway I had deliberately chosen to face such a challenge. Normally I would have taken the subject back to the studio and transformed it by creating a break in the cloud so that the light could filter through onto some selected centre of interest. But here I was trying to avoid such an obvious device. I wanted to prove that even in the dullest conditions it should be possible to select a subject which would work without altering the light. And eventually I found it.

Firstly I looked for as much colour as possible – not easy in such dim light. But here on the left I had scarlet rosehips, and in front the warm browns of dried seedheads and dead weeds. The yellowing grasses were a godsend, for yellow will always suggest sunshine. Secondly I found the maximum contrast of tone that was possible in such conditions – the caves in the rocks. Limestone is so light in tone that it provided the optimum effect of light against dark. Not only had I the Shepherds' Abbey on the left with its relatively small apertures but on the other side of the river were the great, gaping entrances to the Dove Holes. So it wasn't a wasted day after all. The painting may not be the most striking I have ever produced but the restrained subtlety of its detail is very satisfying. It sums up the essential qualities of November quite well.

The dark water is also important as a strong contrast. In order to paint it freely I covered the

surface with the blue of the ripples first, dropping in some warm colour for the reflections of the bank. When it was dry I overpainted with a strong green, leaving the ripple shapes untouched.

This example is quite contrary to the main theme of the book, but I thought I would begin with an example that began at a low ebb but struggled through to a kind of victory in the end. And there will be many such experiences ahead for you in your own painting.

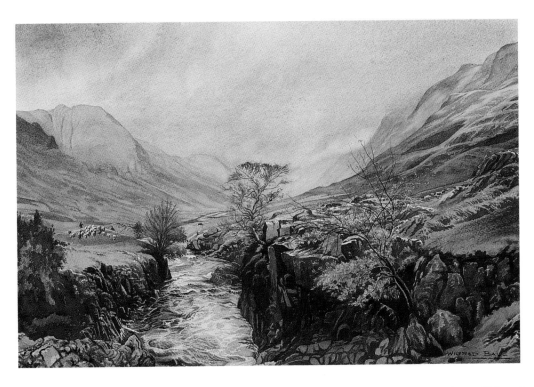

△ *After the Rain, Langstrath, Borrowdale 22 × 15in (56 × 38cm)*

The rain trickled down the window panes throughout breakfast at Swinside Farm in the Newlands Valley. But a creamy glow in the sky beyond Catbells gave us hope as we drove the few miles to Stonethwaite in Borrowdale. Langstrath is a lovely, wild, bare, remote dale but in wet-weather gear the stony track became somewhat tedious as we made our wet way to the footbridge below Stake Beck. Here in summer I've seen a dozen youngsters bathing in the deep blue pot. Today the beck boiled as it tore through the rocky gap.

At this point my eye followed the stream down to the foot of the dale, where an exciting glow was beginning to gild the fells as the winter sun broke through. A perfect example of nature transforming a drab landscape!

When I painted the scene in the studio I began with this phenomenon. I dampened the top half of the paper, brushed in a pale grey for the clouds, then dropped a brushful of diluted yellow ochre into the area of light at the foot of the dale. When this had dried I was able to model the fells with delicate touches of weak colour which maintained the sunny effect and then put in the patches of blue sky. After that I dampened the middle distance so that I could paint diffuse washes of warm greys for the tops of the fells on the flanks of the dale, burnt sienna for the rusty, dead bracken and a few touches of subdued green for grass. These colours were allowed to merge with one another in places and thus served as a muted background onto which stronger washes could be painted when dry.

I begin all my paintings with these simple stages on damp paper. I never paint a cloudy sky on dry paper. Remember that clouds are made up of dust and evaporated moisture and therefore must have soft, diffused edges. If, on a very bright day you feel an occasional crisp edge is needed this can be emphasized when the sky has dried.

A sunburst of the kind illustrated here would have its effect dissipated if there were sunny passages elsewhere in the painting. I was careful therefore to keep the foreground dark and use very strong mixtures for the lowest tones in the rocks.

On the way back to the foot of the dale the sun brought with it a rainbow – then another. I hardly ever visit the Lake District without seeing at least one of these striking phenomena.

▷ *Below Cracken Edge, near Glossop 15 × 7in (38 × 17cm)*

I have painted this picture especially to clarify what I mean by a 'transformation'. On a grey day in Derbyshire the sombre valley was suddenly filled with light as the sun broke through for a brief interval, not to return. On such a day, when the sun has stubbornly refused to appear, this is when the words 'if only' spring to one's lips, as I've mentioned earlier. There is no need for regret, however. Any subject that is structurally sound – that is well composed, but somewhat emasculated by poor light – can be transformed by the introduction of a striking effect like this when you paint it.

I began by wetting the top half of the paper and tinting with pale yellow ochre the sunlit valley and the sky on the right, which is the source of the glow. Then I brushed in the clouds with horizontal washes of pale grey. While this was drying I took a large wash brush and covered the whole of the foreground area with the same blue-grey I had used for the clouds. On dry paper, of course, this dried much darker. I put a brushstroke of yellow ochre into the top edge of the damp wash for the strip of sunlit dead grasses. The essential balance of light and dark in the composition was now completed by putting a wash of the same grey over the jutting shape of the dark edge on the right and the cast shadow to the left of it. I softened the edge of this shadow with a damp brush where it met the sunlit area.

To emphasize the sunny effect all the tints I applied to the sunlit valley were kept clean and pure. Greens and browns had a little yellow added to them to emphasize this. The darker trees were put in with a blue-grey warmed with a touch of red. As a converse to this the tones in the shadowed areas were kept cool by the addition of blue. This contrast of warm and cold, although quite faint in most cases, does produce an overall emphasis of sunlight.

I have seen this kind of lighting effect so often over the years that I have no difficulty in recalling it whenever it is needed.

▷ *Angrams, Swaledale 22 × 15in (56 × 38cm)*

There was no sign of the sun all day when I painted this, but there were compensations. I felt that the view from this 'gateless gateway' summed up delightfully the gay abandon of the switchback road's progress. The light was fitful, but its pearly quality was thoroughly in keeping with the gentle nature of the subject.

Technically what appealed to me were the problems of architectural perspective in a composition where some buildings were above and some below eye-level, standing as I was, quite high above the road. With buildings on many different levels, like these, it is also important that all verticals are genuinely upright. Of all English domestic architecture I think the sturdy stone cottages of the Yorkshire Dales stand supreme. I love to paint them. The James Herriot TV series, shot in this area, has made them familiar all over the world.

It was April and so I introduced the sheep and lambs in the foreground. A picture of the Dales without sheep would be unacceptable. My palette was limited to cobalt blue, yellow ochre, burnt sienna and winsor green.

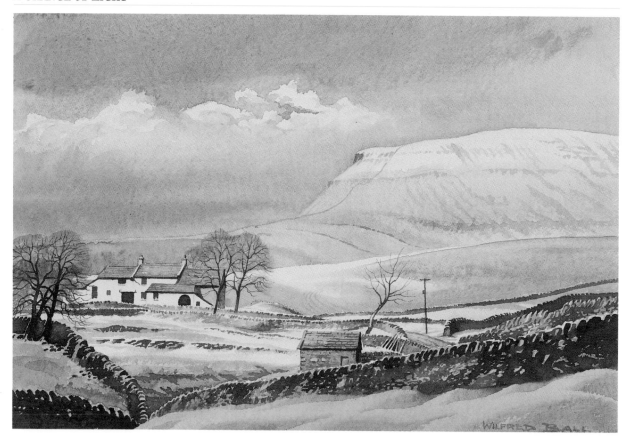

△ *Pen-y-ghent, Ribblesdale, Yorkshire 22 × 15in (56 × 38cm)*

We were on our way over the moor to Halton Gill in Littondale, when the morning mist was quite claustrophobic and there seemed scant likelihood of any reward but the benefits of exercise. But unnoticed the grey veil was thinning and suddenly a great white whale surfaced above the sea of mist and Pen-y-ghent swam into view. This dramatic appearance of one of the three great mountains of Yorkshire provided me with one of my most exciting moments in the Dales. And what a subject to paint! Within half an hour the mist had thinned enough for the higher cloud to show above the warm haze, snow-capped like a range of mountains.

The painting proved remarkably simple. After wetting the area above Dale Head farm, leaving only the tops of the white clouds and the top of the mountain dry, I brushed in a mixture of cobalt blue and alizarin crimson for the warm haze that the mist had now become. Mixing a stronger wash of the same colours I strengthened the upper clouds and the horizontal ones to the left of the mountain, then touched in some cobalt blue immediately above the white clouds, into which I introduced a little modelling. When it was dry I added the few details on the flanks of Pen-y-ghent and emphasized the dark crag overlooking the end slopes.

The foreground snow was treated with the same warm mixture. I added yellow ochre for the sunny roofs, trees and walls. The painting was completed using only three colours.

BRIGHT SUNLIGHT

These are the conditions most popular with the majority of landscape painters – strong tonal contrasts and the potential for dramatic cast shadows to assist with composition. Indeed, when you examine the paintings in this section it is easy to see why most viewers would consider that they are seeing the landscape at its very best.

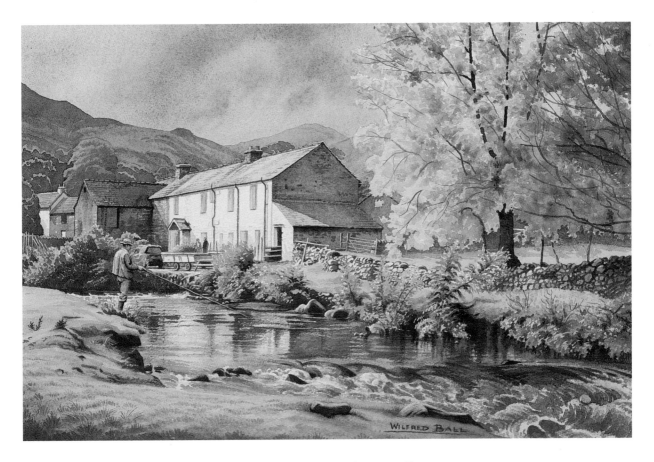

△ *The Long House at Sandwick Bay, Ullswater*
22 × 15in (56 × 38cm)
The lakeside path between Sandwick Bay and Side Farm is probably the most picturesque walk in the Lake District, particularly in autumn. A more appealingly natural composition than this it would be difficult to imagine. The typical white Lake District farmhouse with its cluster of unpainted stone outhouses displays a fine example of horizontal perspective for inexperienced painters to study. Alongside it the bright, golden foliage delighted in the sunshine while dipping its reflection in the glossy stream. The scene was a complete delight to paint.

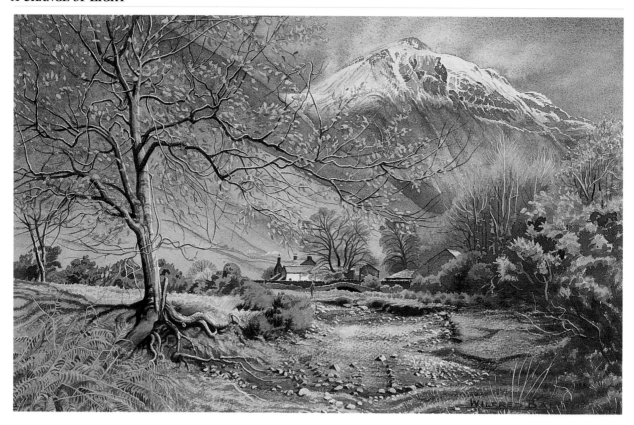

△ *Early Snow on Great Gable, Wasdale Head*
22 × 15in (56 × 38cm)

This is my favourite view of Great Gable which seems to me to relate to Wasdale Head just as strongly as to Wastwater, from where it is more frequently painted. On this particular day it was magical. It is extremely rare for the Lake District to get snow in autumn so this combination of the snow-capped peak beyond the warm October foliage was a gift from the gods. In my opinion this is as perfect a landscape subject as there is.

Wasdale in the 1930s boasted that it had the highest mountain, the deepest lake, the smallest church and the greatest liar in the Lake District. It still has the first three but the landlord of the Wasdale Head Inn died just after the war. The Scafells make it the mecca for English climbers. The bar is decorated with yellowing old photographs of the earliest and greatest climbers as well as some of the most famous crags. It was from the back door of the bar with a pint in my hand that I stepped last October to cross the famous packhorse bridge, which can just be espied on the painting, and walked a hundred yards down the path to get this marvellous view.

It was quite a complicated subject to paint, as you can see. The details of the trees and foliage and the stones in the foreground necessitated a couple of hours work with pen, brush and masking medium

to ensure that all this detail was adequately treated before I could start to paint. Starting with the sky, I wet the whole of the paper above the farmhouse except the snowy part of Gable and put in the grey cloud on the left, over Kirk Fell, the shadow below the top of Gable and the sky area, just interrupted by the patches of blue. I strengthened the grey colour, cobalt blue and burnt sienna, slightly on the left so that the dark spaces between the sunlit twigs and foliage would show them up better.

Without waiting for this to dry I took a large wash brush and painted the rest of the picture surface with washes of background tints: pale and darker green on the left for the grass and gorse bushes, autumn colours on the right for the bushes and trees in the middle distance. Because the paper was dry the colours would dry stronger than the tints in the wet-in-wet area at the top. The freedom and confidence with which I was able to paint were due entirely to the protection of delicate detail and highlights with masking medium.

After this stage it became apparent to me how important the blue of the little stream in the foreground was going to be. It echoed the blues and blue-greys in the top half of the painting and at the same time prevented it from being a painting of two halves. To have only cool colour in one half and warm in the other would have destroyed the balance of the composition and especially the colour

relationships. In landscape paintings as in the actual landscape there should be repeated echoes of warm and cool colours all over the place. As in music this is what produces the rhythm and harmonies that in turn create a unity.

I finished off the mountain next, using blued-off tones to keep it firmly in the distance. Just as yellow shouts 'sunshine' to me, so blue means distance. Always paint backgrounds in blues and blue-greys. If the sun is shining in the distance just add a touch of diluted yellow ochre to the south-facing slopes of hills or the sunny side of trees while these washes are still wet and it will merge gently into the cool colours in the unobtrusive way that all background effects should. Basically, however, all yellows, reds and browns, which we call warm colours, are foreground colours. They appear to come forward in the landscape while the cool colours, blues, shuffle off quietly into the distance. For this reason we consider them to be receding colours. If you use warm and cool colours in this way you'll have no trouble in achieving the effect of recession in your pictures.

Wasdale Head. Where else could you step out of a pub to a scene like this? Isn't the mountain magnificent?

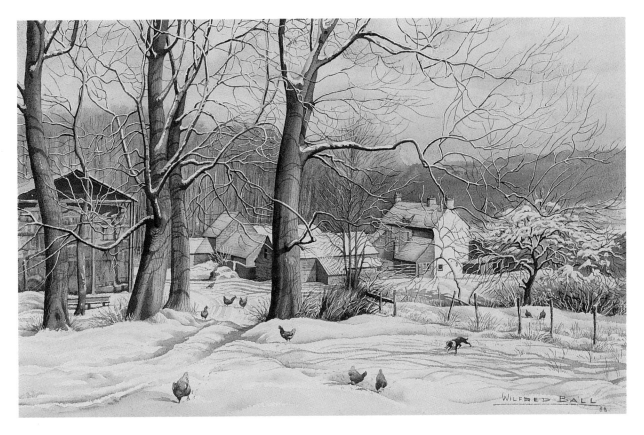

△ *Winter Shadows, Windley 22 × 15in (56 × 38cm)*
This is another example of one of my transformations. I actually sketched this subject on a bright winter morning when there was no snow on the ground. But my fond memories of similar sunshine on snow· persuaded me that it would look even better as a snow scene. One of the advantages of working from a black and white sketch is that it looks like a snow subject to begin with. I have painted so many of these that it is quite a simple process to carry out the transformation. In other words, this painting is exactly like one of the classic definitions of poetry – moments of excitement recollected in tranquillity.

Another reason for the decision was the colour of the brick buildings, which brings a note of cheerfulness to what might otherwise be a chilly scene. Many people have a psychological aversion to snow scenes for just that reason. Farmyards also have animals about so one is readily supplied with interesting local colour. Black and white Friesians would not have done very much for the warm accents in the subject but brown chickens most certainly did, so I decided to focus on their activities. The stalking dog was a late addition.

△ *Harter Fell from Eel Tarn, Eskdale 15 × 11in (38 × 28cm)*

It was raining as we set off up the track beside Boot Mill and uphill to open country. The sky was most dramatic, with huge cumulus clouds scudding along at a rate of knots as we approached Eel Tarn. I was glad I was wearing wellingtons as we squelched along. As so often before, they were proving more serviceable on the moors in wet weather than boots. The sudden flash of light from my right caused me to lift my eyes from where I was putting my feet, to find the reedy margins of the tarn bathed in light. What made the light seem so bright was the contrast with Harter Fell, inked indigo by the shadows cast by the mountainous clouds – which moved on. Ten minutes later all was dark. All that remained of the visual encounter was its impact on my retina. Many years later I could paint the subject from memory, so powerful had been the image – as you can see. Once or twice more during the day the sun threw aside the cloud for a few minutes, but never to such telling effect.

Painting the sky was invigorating. After wetting the area plus the mountain, I put in strong grey cloud shapes which I strengthened when they were nearly dry. The blue patches were also added while it was damp but I waited until the paper had dried before adding the stronger blue in the centre as I wished to leave crisp edges. I added more blue to the cloud mixture before painting the mountain. The important thing was to make sure the foreground was light and warmly tinted enough to provide the necessary contrast with the mountain.

Reflecting the dark clouds, the stream also emphasized this tonal contrast. It only takes a moment for nature to show off like this. If I returned twenty times I wouldn't see its like again.

▷ *Fresh Snow on the Fannichs 15 × 22in (38 × 56cm)*
We were staying in Ullapool. One morning we woke to see a sprinkle of snow on the tops. But it was not until later in the day, when we approached the Fannichs, that we were able to see the snowfall on these higher peaks. And what a sight! Compared with this the dusting of snow on Great Gable in 'Early Snow on Great Gable' (page 18) looked quite trivial in retrospect. Here it trailed a frieze of ravishing blue and white across the cloudless azure sky. The counterpoint of autumn colours below was most exhilarating. I suppose this really is the ultimate in visual excitement, when a sunlit range of snowy peaks is poised above an autumn landscape.

Painting such a magnificent subject is rarely very difficult. Being there at the right time to see it like this is the difficult part. The sky and snow were painted in graduated washes of pure cobalt blue. Only one thing had to be altered. In the original scene the brownish-grey stratum below the snow-line drew a continuous obtrusive line separating the cool colours of the top from the rich colours of the foreground. To destroy this unfortunate division I painted the trees rather taller than they actually were, thus overlapping the snow area in a more pleasing way. Decisions like this, in the design stage of a painting, are more important to the end result than how the paint is applied.

WILFRED BALL

BACK LIGHTING

Commonly described by the French phrase *contre jour* – against the light – this is one of the most dramatic of all lighting effects. The sun shining onto leaves seen from the front cannot compete with the brilliance of colour produced when seen from the other side, against the light, when their translucence adds a luminosity which, because it is usually emphasized by a dark background is all the more potent. Back lighting highlights edges and is quite blinding in wet weather when it silvers all the wet surfaces and picks out shiny leaves as they sway and sparkle.

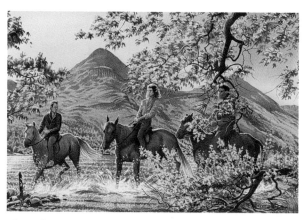

△ *Below High Stile, Buttermere 22 × 15in (56 × 38cm)*

This subject is a real celebration of the *contre jour* phenomenon. The silvering on the riders' hair and the horses' backs is characteristic and the yellow green of the new Maytime foliage is suitably bright. But what really caught my eye was the constant explosion of sparkling spray kicked up by the horses' hooves as they moved through the shallows. Dark against the sun, High Stile provided a suitable background to emphasize all these highlights.

Because of its proliferation of small highlights, the sunlit drops of water and the sunny leaves, a great deal of preparation was necessary before starting to paint. All the yellow leaves, the highlights on the figures and animals and finally the bright water had to be painted in with masking medium. This allowed me to paint in the background with a large brush and a feeling of complete freedom from any of the constraints the fine detail might otherwise have imposed. I am not an expert on painting horses, although I'll have a fair shot at painting any animal reasonably accurately, but the fact that the horses were very dark relieved me of a certain amount of indecision about parts of their physiognomy.

Once again this is another example of a picture that owes its impact to the work done before I applied the first wash of pigment. Think before you begin: there may not be time afterwards.

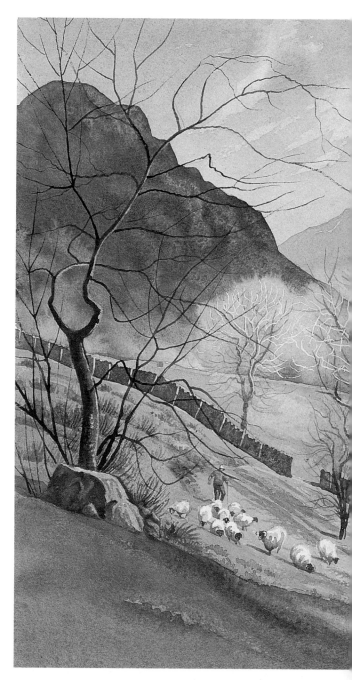

▽ *Red Pike from Crummock Water 22 × 15in (56 × 38cm)*

Like the last painting this depicts trees backlit. However, here it is early April and no leaves have yet appeared. In these circumstances the light-coloured twigs of the ash and willow trees glow in the sun like a halo. Because they are further away this is a much more delicate, softer effect than in the Buttermere picture.

As with the latter I began with masking medium. With a pen I put in the tracery of twigs on the nearer trees, which was all that was necessary. I decided I could paint around the sheep quite easily. I began painting with the sky, as usual applying the tints onto dampened paper. These washes were brought down over the mountains as far as the water's edge. They were too pale to interfere with the colours of the fells, which I applied as soon as the sky washes had dried. Although applied quite broadly and simply these washes involved one little problem of manual dexterity. Just below the peaks were thin drifts of snow in the crevices, which had not yet melted in the sun. I had to be quite careful in painting them to keep the washes fluid so that unwanted hard edges should not appear.

A limited palette was used. Apart from the sweater (alizarin crimson), I used cobalt blue, yellow ochre, burnt sienna and winsor green.

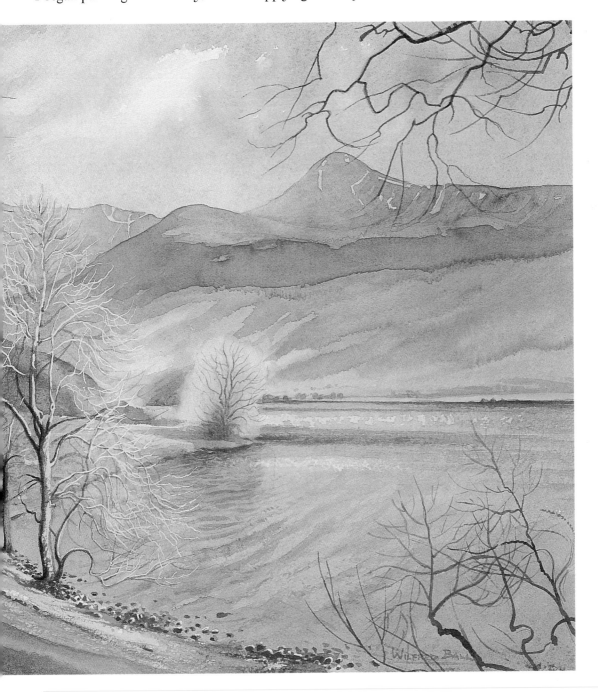

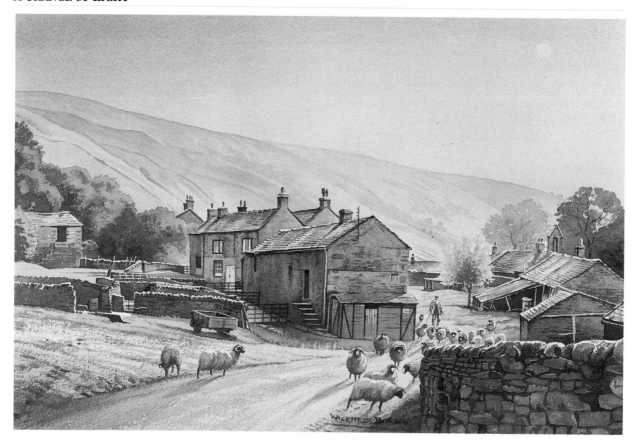

△ April Morning in Halton Gill, Littondale, Yorkshire
22 × 15in (56 × 38cm)

A couple of weeks later in April than the last subject, this still has the same delicate colour and the gentleness of early spring. All landscape paintings must capture the desired quality of light and the essence of the season, as well as those topographical details that give it a sense of place. This subject is a typical Yorkshire scene and my aim was to capture that quality as well as enjoying the simple, sturdy architecture of the Dales.

It was going to be a lovely day and I was keen to capture the creamy light as the faint sun began to show through the early morning haze. The focal point was the backlit sapling between the barns and the farm buildings. Glowing as it did in the morning light it provided a contrast of form and delicacy with the solidity of the buildings.

The key to the mood of the painting was, as usual, the sky. On a damp background I applied a blue-grey at the top, graduating into yellow ochre below. This carried down over the fells so that the creamy glow suffused the whole background, a telling foil to the darker patterns of the buildings in the foreground. Even there, though, there were no really powerful darks and the final effect was one of carefully modulated greys against the lovely light. A very gentle example of *contre jour*.

Sunlit Rowan above Ullswater 22 × 15in (56 × 38cm)
(Above right)

Walking south on the lakeside path on the eastern shore of Ullswater and looking into the early evening sun, we approached this mountain ash with great excitement. Backed as it was by the dark fell it glowed and flamed. Had it stood against the sky it would not have been nearly so impressive. You always need dark to emphasize light.

The top left-hand corner was the chief problem. I had to keep the hillside dark immediately behind the tree but show the sunlight streaming across it from above. The sky had to be painted carefully to retain the backlit edges of the creamy clouds. After putting in the distant fells I painted the dark hillside with a wash of dark warm grey. When it was dry I used a damp hoghair brush to fetch off some of this colour in diagonal strokes to create the shafts of light. I put ultramarine blue on top of the grey immediately behind the tree for extra impact.

When the picture was finished I used a knife to scrape off pigment around the edge of the foliage to emphasize the halo effect created by individual gleaming leaves: a much more dramatic *contre jour* effect than the previous one.

Gleaming Snow above Bradbourne, Derbyshire
22 × 15in (56 × 38cm) (See caption overleaf.)

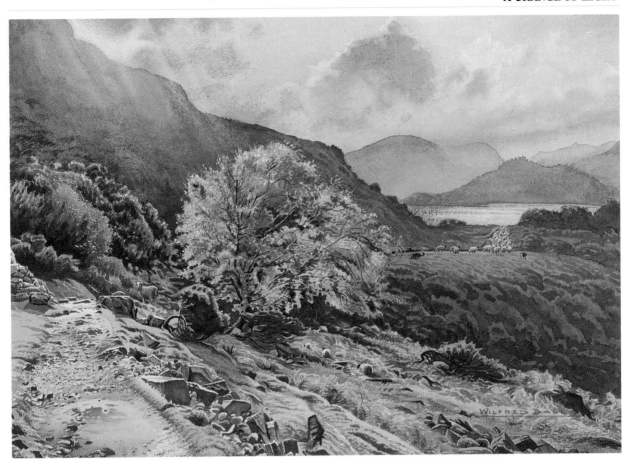

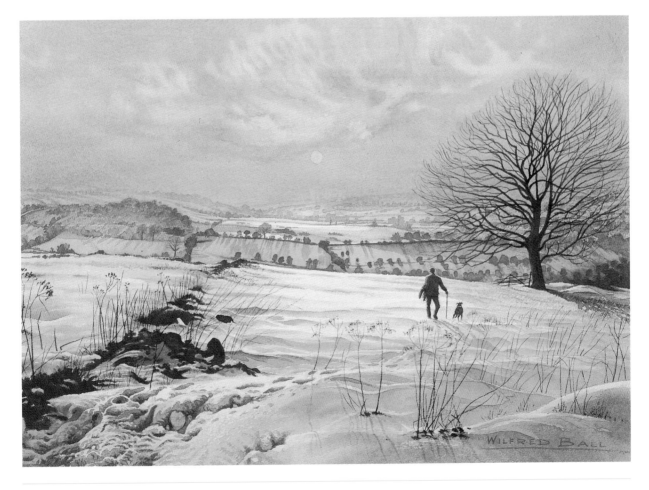

(Previous page, below right.)

Gleaming Snow above Bradbourne, Derbyshire

We had been sketching all day. In order to make the most of the last hours of light we had then clambered up the slopes to this field of snow which looked back towards Ashbourne. It was getting colder. Our breath began to be visible. In the hedgerows, frost was icing the undergrowth. Fine cobwebs thickened with rime. The sun was sinking into a golden glow that would soon become orange and then red. In the distance the tree-fringed fields were settling into a sea of mist, except for a swathe of light across the fields in the centre where the untrammelled snow gave it free passage. Leaping the intervening valley it poured towards us. The snow had begun to melt during the day but now the frost polished the icy surface until it gleamed. Snow-drifts turned their creamy faces to the light while their silver shadows edged into the twilight hollows.

Under a blue sky snow looks cold, the blue shadows sharpening this sensation. But let the snow reflect the evening sky and all is transformed into gold and pink and lavender, a seductive spectrum that I cannot get enough of. Snow scenes are my favourite subjects.

When I began to paint this one I put the sky in wet-in-wet, using cobalt blue and yellow ochre, which I carried down over the middle distance except for the soft strip of highlight in the centre. The sun had earlier been protected by masking medium. Before it dried I brushed a little cadmium yellow into the sky immediately around the sun then put a pale wash of cadmium red into the yellow just above the horizon. As it was still damp this seeped into the misty distance, breaking down the distinctness of the horizon. When this was dry I was able to suggest the clusters of trees and hedges with weak washes of blue. While doing this I put in the shadows cast by the trees standing on the rim of the valley, long shadows which slanted impressively down the slope. Although small, these shadows were the most significant reason for me longing to paint the subject. The background was completed by rubbing the medium off the orb of the sun, then tinting it with very pale yellow. Leaving it white would have given it too much prominence. A slightly stronger blue-grey was mixed for the nearer of the distant trees.

I began the foreground with a wash of pale yellow ochre over everything but the bright gleam in the centre. When this had dried I put in the blue shadows on the snow, leaving the top edges crisp but softening the lower edges with a damp brush. I

strengthened the colour as I came nearer to the bottom of the paper. In the hollow on the left where the sheep had been sheltering during the long hours of night the trampled marks were emphasized with a really strong blue-grey. It was then time to emphasize the delicate tones of the snow by putting in the contrasting dark objects. The tumbled stones of a derelict wall snaked across the snow towards the sun, the tall seedheads of dead cow parsley standing amongst them. A powerful blue-grey of cobalt and burnt umber was mixed for these darks while the umber alone was used for the tufts of short vegetation which were catching the warm light of the sun. The spindly cow parsley in the central

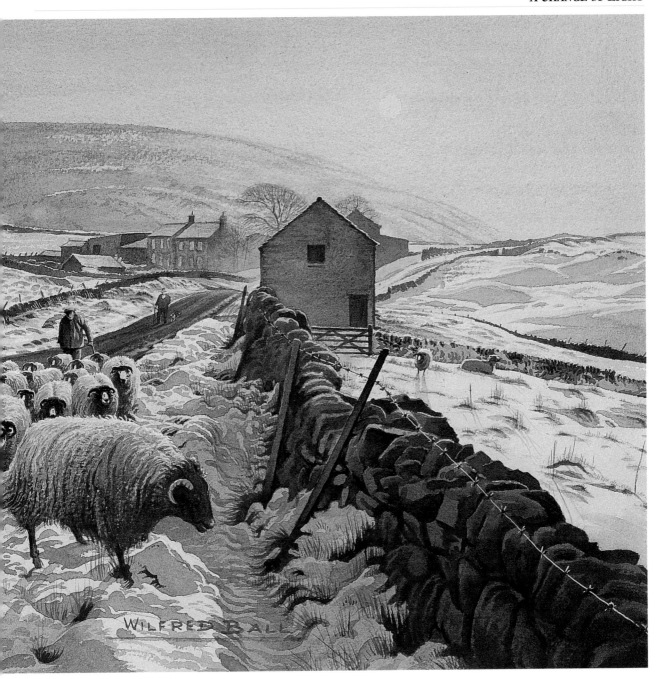

foreground was more delicately treated. The seedheads themselves, gilded by the sun, were touched with yellow ochre. The varying angles of the light will ensure that all seedheads will be lit differently and it would be a serious error to paint them all in exactly the same colour. In the same way, when I painted the tall tree in a cool dark grey I put in the twigs on the side nearest the sun with a warmer colour, burnt umber. Finally the receding figure was touched with yellow ochre on the left and I was careful to leave a thin edge of untouched paper around the head and shoulders to prevent the head merging with the dark background. I was gratified by the final result.

△ *Golden Fleeces, Oxlow House Farm, Castleton*
22 × 15in (56 × 38cm)

A little later in the evening than the previous subject, this painting is bathed in an even richer, more mellow glow. It is a much more dynamic piece of work. Its darker tones, its greater tonal contrast, and the more diagonal thrust of its structure compare with the clearly horizontal composition and gentle colour harmonies of the Bradbourne painting. A dramatic quality has replaced the peaceful, reassuring mood of the former.

I can clearly recall looking down the moorland road into the sinking sun and seeing the dark, amorphous bleating blur appearing slowly out of

the misty hollow by the farm buildings. As it approached it was possible to feel a distinct increase, not only in the amount of noise but also in the sense of drama that progressively imbued the scene. By the time the flock had reached the position shown in my painting the tangled backs of the animals were gilded by the long, low rays of the setting sun. This is *contre jour* at its most dynamically appealing.

The success of a painting depends on a clear initial assessment of the mood that will permeate its final appearance and then on achieving that mood. In both these paintings I sought one common element, nostalgia, which I think I achieved. But apart from that sentimental essential the moods are quite different: calm tranquillity in one and purposeful activity in the other. And the rich light pours its blessing over both. Technically there was not much difference in the way they were painted, except for the much more powerful tones used in the final stages of the second.

You will see from these two works why it is that the painter loves the evening light. There is a strong psychological appeal in the mellow colour and endless powerful possibilities in the long shadows. In a recent exhibition I felt that this particular picture was the one most popular with the viewing public. It clearly recorded a moment to remember, in a moorland area of the Peak District which is dear to my heart.

Donkeys.

▷ *Silver Stream, Upper Eskdale from Lingcove Bridge 11 × 15in (28 × 38cm)*

This is 'backlighting' *par excellence*. There are hundreds of backs to be lit, all the way down to the foot of the dale. We were sitting below the cataract behind Lingcove Bridge late one October afternoon, enjoying a cup of tea. It had been a glorious if hazy day and we were on our way back from that marvellous uninterrupted view of Scafell Pike that Upper Eskdale provides (see page 69). Admiring the molten silver of the River Esk, on its winding way down to a distant sea, we suddenly became aware of a string of sheep approaching us. By the time they crossed the bridge they reached back into the haze as far as the eye could see, their rounded backs picked out by the sun. The sheep had been driven off the fell a few days earlier and taken down to the farm for the fully grown lambs to be separated from their mothers. Those animals not kept back for the next market were being allowed to make their own way back, not a farmer in sight, to the fell. In these circumstances all sheep will instinctively head back to the same hillside, or 'heaf', from which they have been fetched.

The painting was a comparatively simple procedure after protecting the sheep and gleaming water with masking medium. All except the foreground was painted wet-in-wet, the tones being strengthened as they moved down the paper. When it was dry, I took out the faint shape of the sun with a hoghair brush dipped in clean water, then put in the distant fells with pale blue and blue-grey. The slopes were warmed with washes of diluted burnt sienna, before the darker details were put in with a stronger blue-grey mixture. A low-key colour scheme was essential to show up the highlights which were the focus of the composition.

In painting the foreground I used sap green mixed with a little raw sienna to produce the colour of the turf, warmed by the creamy light characteristic of this time of day. The shadow under the bridge was very strong. After an initial wash of burnt umber mixed with cobalt blue I put in the details and the intense shadow under the arch with one of the strong greys I've mentioned earlier in the book – ultramarine blue and alizarin crimson – a really powerful mixture. After removing the masking medium I painted the sheep, subduing the highlights on their backs somewhat. As their wool is a darkish grey in colour, unlike other English sheep, the Herdwicks' fleece caught the light only slightly although their pure white faces and legs more than made up for this.

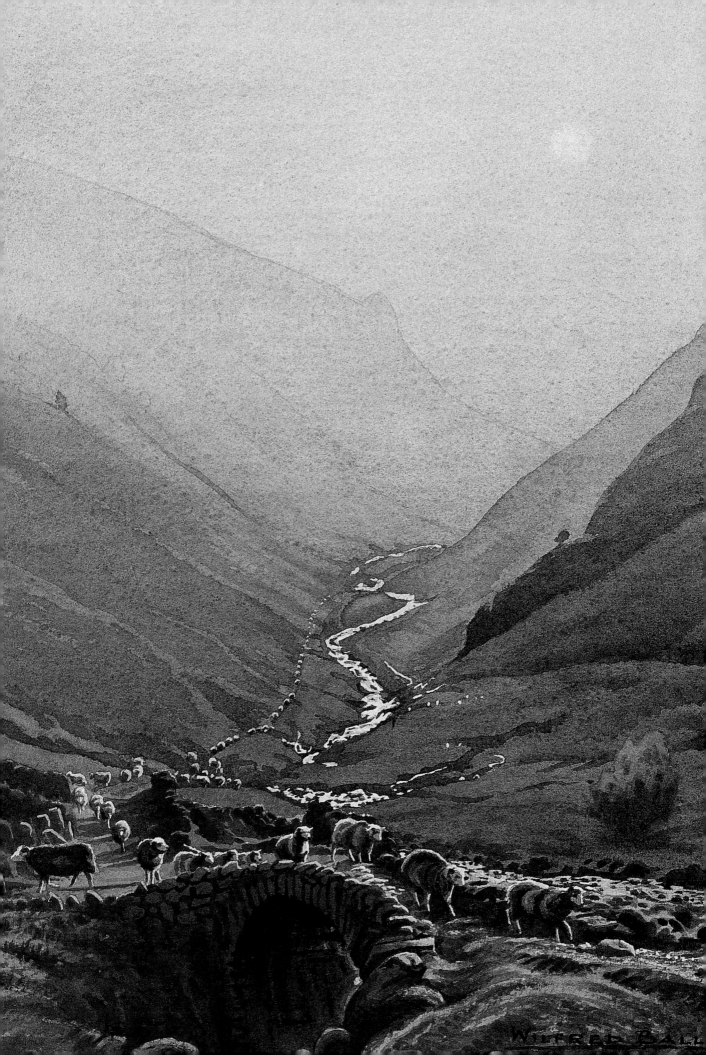

WILFRED BALL

FITFUL LIGHT THROUGH CLOUD

This is the phenomenon which more than any other can snatch triumph out of disaster. How often have I spent a day under dripping grey skies only to have my bacon saved when the light seeped slowly through for long enough to enrich the landscape and show me another fine subject to paint. All three of the paintings that follow appeared just momentarily on days that were alike in their galling greyness. Here are three heartfelt thanks to the rare gaps that appeared in the cloud.

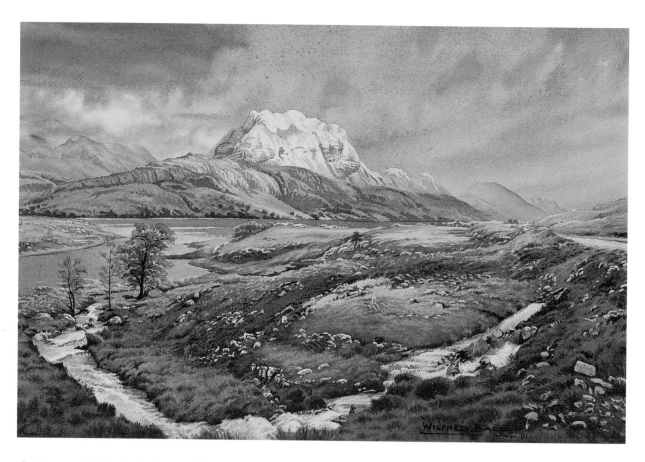

△ *Snow on Slioch, Loch Maree, Wester Ross 22 × 15in (56 × 38cm)*

Slioch is an impressive mountain. I don't know what the name means but it should be Citadel or Rampart, so much does it resemble a rocky castle. To see it across the lovely Loch Maree is to add to its imposing appearance. It would not have imposed on us in the slightest as we drove towards it through mist and drizzle one October day. Its silhouette could barely be seen, but hope was inspired by a lifting of the cloud and we parked by the Loch to await better things. As you can see, better things we got. Although the cloud remained livid throughout, a number of blue windows opened and the mists pulled away from Slioch.

The sky was completed wet-in-wet. Here I did something I've never done before or since, mixing a little green into the blue-grey of the clouds to produce the ominous, bruised look they had. The mountain and loch proved reasonably straightforward to paint, but the foreground ended up being quite tedious. Because of the rain all the scattered boulders presented shiny surfaces. I had to mask them all out before I could start to paint but they were essential to create that wild, bleak, untidy appearance of this lovely moonscape of a moor.

As the cloud shadows scudded across the foreground the sunlit patches showed only fleetingly so I took a couple of quick photographs intending to make my mind up in the studio how to arrange the light and shade. This I did, to the optimum dramatic effect, keeping the base solidly dark and placing the sunniest areas immediately below the dark shadow along the base of the mountain.

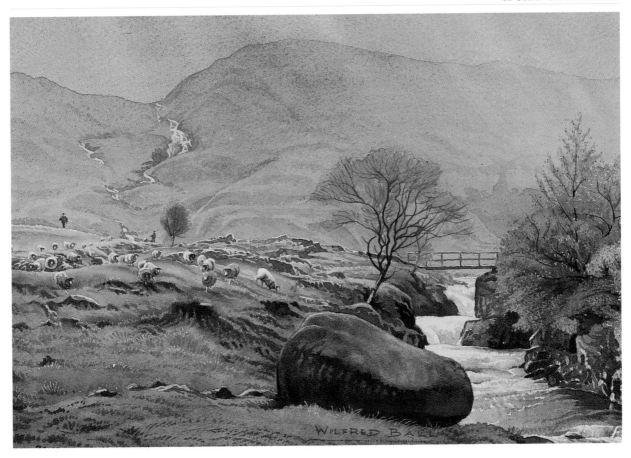

△ *Below Stake Beck, Langstrath, Borrowdale*
15 × 11in (38 × 28cm)

Stake Beck, which is here seen tumbling down the distant fell, marks the route of the Stake Pass over to Langdale.

Before starting to paint I used masking medium to protect the distant torrent as well as the sheep's backs and the shiny wet edges of rocks and walls. These touches, though small, were crucial to the theme of the painting – the effect of sun after rain. I quickly washed pale grey over the whole of the background then drew a wash brush full of weak yellow in diagonal strokes across the wet wash to give the effect of weak shafts of sunlight. When this was dry I put in the background fell with the same mixture I had used for the sky, adding a little dull green on the lower slopes. Slightly stronger touches of grey were used to emphasize the course of the beck before I rubbed off the masking medium and subdued the water with a little pale blue.

As is often the case, this first stage fixed the mood for the whole of the painting.

Showery Afternoon, Langstrothdale, Yorkshire
15 × 11in (38 × 28cm) (Overleaf)

Langstrothdale is often called Upper Wharfedale as the infant River Wharfe begins here. As in the previous painting, I was trying to capture the subtle misted colours after rain being slowly illuminated by a hesitant sun. An interesting technical hint: the soft clouds were created by wrapping my finger in an old handkerchief and dabbing off pigment while the sky was still damp.

The key to success, however, was the glistening wet effect. I touched in the gleaming edges on the barn roof with masking medium but decided I would carefully paint around the rest of the highlights such as the top of the walls and the sheep. In painting the road I waited until the warm grey had dried then painted on a wash of pale blue for the reflection of the blue sky immediately overhead. I had put the farmer and his sheep in for local colour as well as to create the focal point in the picture, but note their dark reflections which further emphasize the glistening wetness of the road surface. The patch of sunlight creeping across Buckden Pike in the background is well observed and essential to both mood and composition.

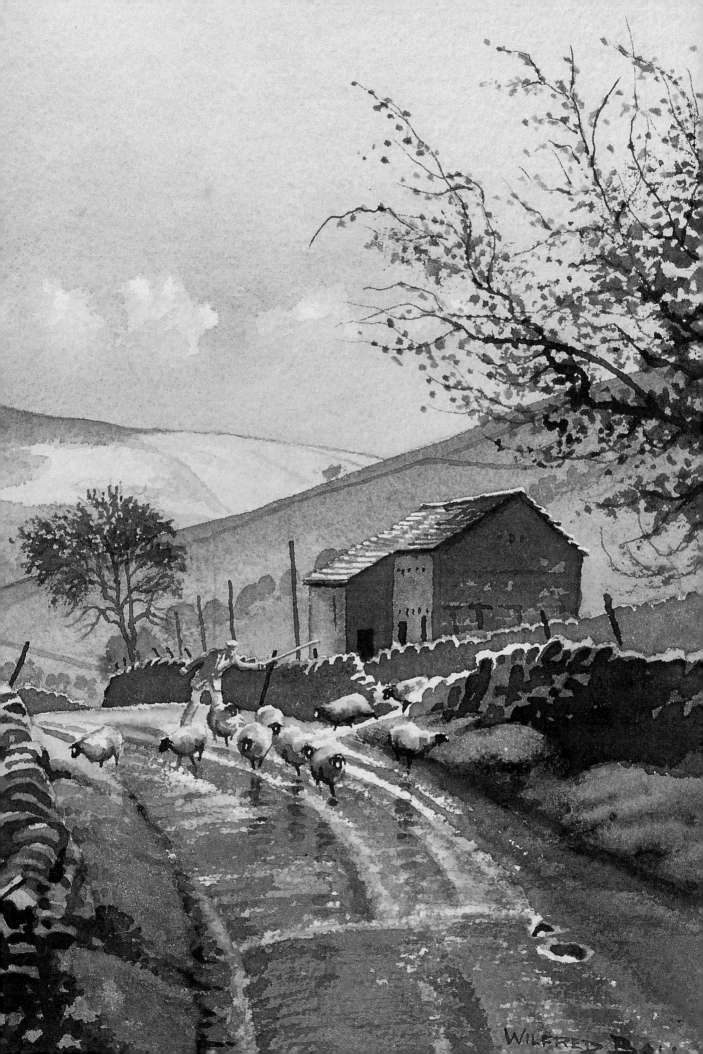

RAINBOWS

Rainbows appear during and after a shower and are a result of the raindrops refracting the sun's rays and splitting them up into the colours of the spectrum. There are a few phenomena connected with rainbows that will help you to paint them. The red is always on the outside and the sky inside the arc is darker than that outside. Sometimes a fainter subsidiary bow can be seen.

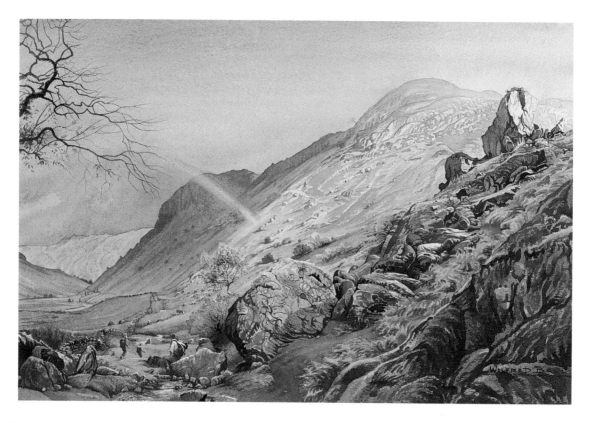

△ *Rainbow in Langstrath, Borrowdale 22 × 15in (56 × 38cm)*

I mentioned in my description of 'After the Rain' (page 13) that we saw several rainbows that day. This was one of them. I've seen literally hundreds in the Lake District. A function of the weather? Here I caught it just as it was fading. Indeed against the light background of the sky it was virtually invisible, but glowed briefly across the dark shape of Eagle Crag. How gloriously it lit the dead bracken on the rocky slopes of the fell.

A rainbow is one of nature's most beautiful manifestations and I cannot resist them. But they are extremely difficult to paint. Keeping the colour pure and yet getting it to merge gently into the background colour is the problem. In this and 'Rainbow over Fairbrook Valley, Kinder Scout' (page 11) the method I used was to paint the backgrounds in first, then wash the pigment off with a stiff hoghair brush where I intended to put the rainbow. The colours were then applied one at a time while the arc was moist, using a wet brush to soften the overlap of the red and blue at the edges. It is extremely skilful work maintaining the shape of the bow accurately. The trouble with this method is that you will never get *all* the pigment off with the stiff brush. If you try you will end up destroying the surface of the paper.

The only hope of catching the true luminosity and purity of the colours is to apply them directly onto perfectly clean untouched paper. This I did with 'Rainbow over Stonycroft Gill' (page 35), damping the arc before applying the sky and background and not allowing the colours to run into it. This is tricky but possible. As you can see, it enabled me to produce a much cleaner set of tints than in the two other rainbow paintings, yet the background colours at the edges of the rainbow were softened quite satisfactorily.

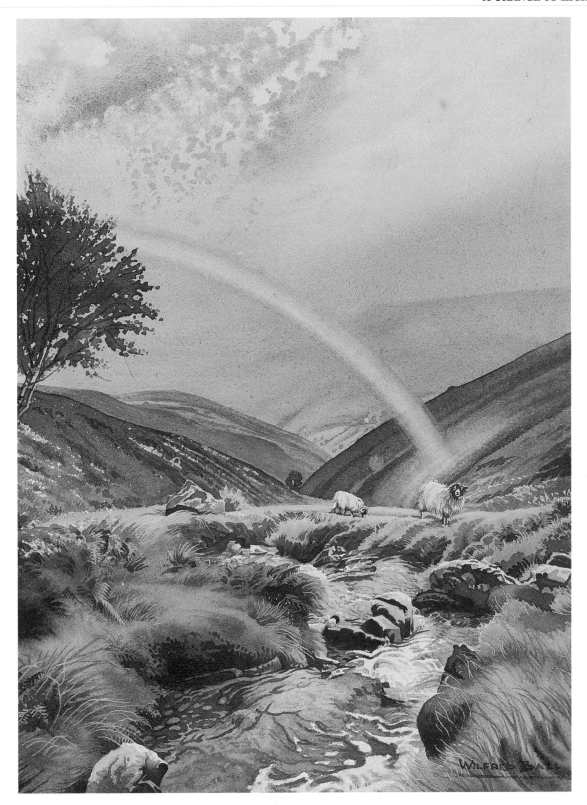

△ *Rainbow over Stonycroft Gill, Newlands 15 × 22in
(38 × 56cm)*

We had climbed Rowling End to get onto the
heather on the slopes below Causey Pike when we
looked across the valley to see even finer fields of
heather on Barrow. On the trek over we stopped by
a stream to eat our sandwiches and were regaled
with this super show. There would have been
nothing particularly remarkable about the scene,
other than the rainbow, if the heavens hadn't
cleared to present the first signs of a beautiful
mackerel sky. This unusual combination was
irresistible.

COUNTERCHANGE

Counterchange is that phenomenon when a dark shape against a light background competes visually with a light shape against a dark background. The supreme example, however, is when, against the *same* background, one object looks light and the other dark. I don't think I've ever seen a better example than the one I captured in the painting on the right.

(Opposite) ***Suilven and Cul Mor, Wester Ross 22 × 10in (56 × 25cm)***
This view is from that marvellous moorland road from Inverpolly to Lochinver and Drumbeg, considered by many people, including me, to be the most picturesque stretch of road in the Highlands. I caught it when the low evening sun was just skimming the snow-blanketed hummocks of the moor. In another ten minutes the entire stretch of moorland would be in shadow and only the mountains would enjoy the rosy light.

Cobalt blue, burnt sienna and cadmium red were the only colours that I used. To produce the rough sparkle on the road I scraped off the highlights with a knife.

▷ ***The Langdale Pikes from Oak Howe Farm 30 × 15in (76 × 38cm)***
Walking along the river from Chapel Stile this is about the first opportunity to get a good view of the Pikes, the sight that draws all eyes in Great Langdale, and one of the great classic views of the Lake District. This is a marvellous landscape subject, sunny but with dramatic cloud shadows, a fine farm, autumn colours, and the Pikes sunlit against a dark sky.

The painting provides numerous examples of counterchange. Two of the most apparent are provided by the farm itself on one hand and the Pikes on the other. The dark fell in the centre and behind the farm provides at the same time a dark background to the sunlit roofs and a light background to the shadowed gable ends. On the right the dark sky shows up the sunlit Pikes and at the same time shows lighter against the darkness of the central fell. Jumping from light against dark to dark against light the eye skips across this composition finding great delight in this visual stimulation. Just for fun, see how many examples of counterchange you can find.

There are two important points about composition which are worth noting. Firstly notice how important are the shiny black plastic bags of hay in emphasizing depth on the right of the painting. Secondly note the shadow right across the base of the picture. If this had not been put in, the sunlit greens in the bottom half would have been greatly outweighed by the heavier tones in the upper half. A composition that is tonally topheavy is always to be avoided. Psychologically we cannot accept it. Note how Rowland Hilder always washes a strong shadow across the bottom of his landscapes for this very reason.

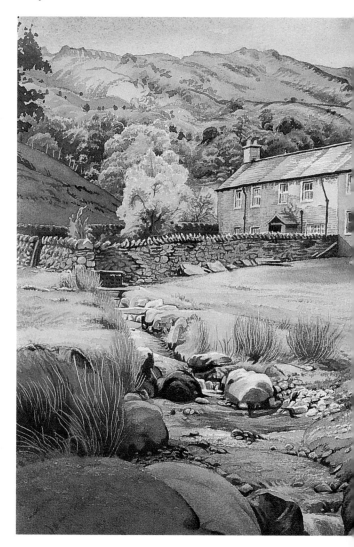

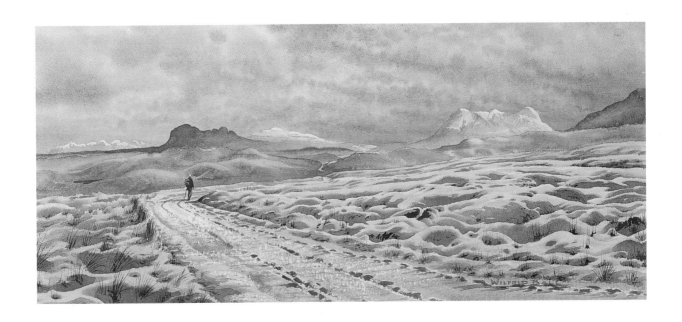

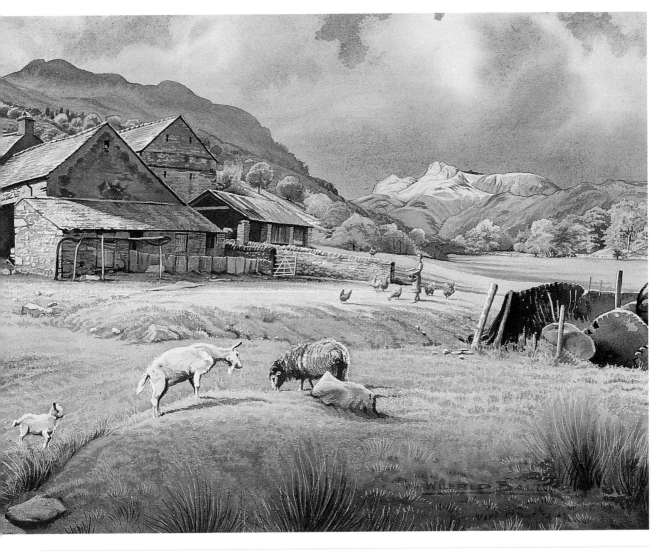

2

SKIES

The painting of skies is at the very heart of landscape painting. Not only does the sky set the mood of the painting, but I consider that if you can paint a good sky you can paint anything. All the skills and subtleties of watercolour are involved in the process. Surprisingly, too, complex cloudscapes are not the most difficult skies. As always in the arts, simplicity is the most difficult quality to achieve. With no detail to hide behind, painting a cloudless sky will test your capabilities severely. In the following examples you will see all types but I begin with one of the difficult, simple ones.

▷ *May Morning, Wastwater 22 × 15in (56 × 38cm)*
Great Gable from Wastwater is another of the classic views of the Lake District. On this particular morning the springtime sky was free of cloud and snowy seagulls were wheeling before the hazy blue. A slight breeze was ruffling the surface of the lake and breaking up the reflections of the fells. The sky is a good example of a graduated wash. At the risk of boring my more experienced readers, here is how I painted it. Normally I paint with my drawing board flat on the table, but before painting any large wash like this I put a book under the far side so as to tilt it gently towards me. First I mixed a plentiful amount of colour, a touch of alizarin crimson in the cobalt blue to suggest a hazy blue. With a large brush copiously charged I passed it across the top of the paper. The angle of the board caused the pigment to run down to the lower edge of the brush stroke. A second stroke below and just touching the first took up this surplus and carried it a little further down the page. After two or three such strokes I diluted the mixture a little with clean water and carried on with the same procedure. Gradually diluting the wash I completely covered the sky area in about fifteen strokes of the brush. I had earlier painted in the shapes of the seagulls with masking medium so that I could draw the brush straight across them with impunity.

A flat wash is painted with exactly the same procedure but the paint mixture is not diluted. However, a flat wash is hardly ever needed in landscape painting. Nature will always err on the side of variation rather than monotony.

This painting's hazy blue-grey colour scheme is characteristic of the time of year, which is confirmed further by the may-blossom overlooking the lake.

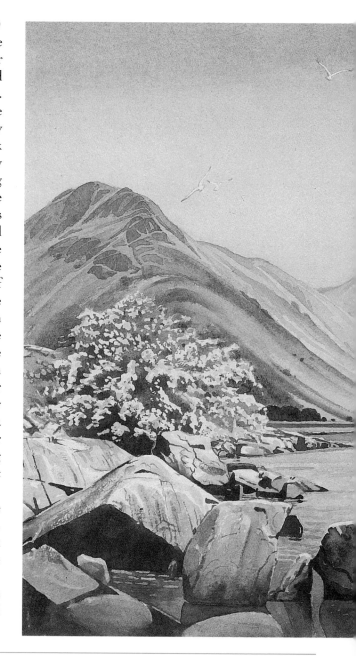

CLOUDSCAPES

When the structure of the clouds becomes so detailed, complex or dramatic that it threatens to dominate the composition, the latter is as much a cloudscape as a landscape. In these circumstances it is important deliberately to restrict detail in the landscape to avoid an impression of clutter and fussiness in the total composition. The following two paintings are good examples.

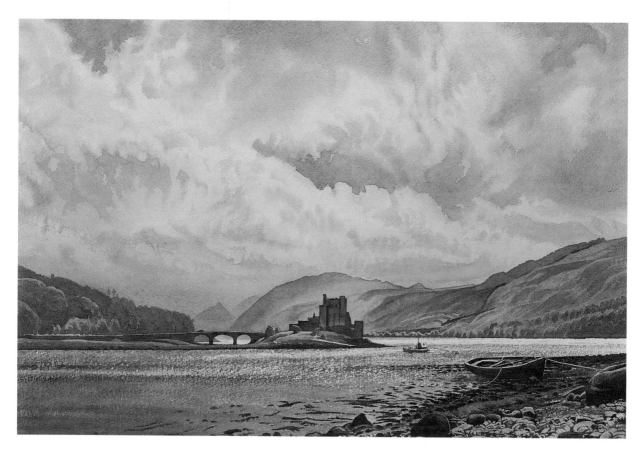

△ *Eilean Donan Castle, Loch Duich 22 × 15in (56 × 38cm)*

Jutting out into the Loch from the road to the Kyle of Lochalsh this famous castle is always paintable. Huge clouds scurried across the late afternoon sky while the choppy water intermittently sparkled or grew darker as the cloud moved over the sun.

As I have already explained, I always wet the paper before painting clouds, after putting in a few faint pencil lines to indicate the main masses. It is important to locate the most distinctive cloud edges and note the direction of the wind before starting to paint. I observed how the upper clouds were swirling in an anticlockwise direction. I began by putting in a creamy wash just above the horizon. These clouds are the most distant and therefore need subduing so that there are no clear highlights on them. I usually put a faint wash of pale pinky-

grey, or of yellow ochre according to the time of day, to drive back these lower clouds, which will always look more horizontal because we are looking at them from the side, where we can see their flat bases. Only with the higher clouds, which we are viewing from underneath, can we see full, rounded shapes.

The blue-grey detail which explained the shapes of the clouds had to be put in quickly before the paper could dry, being particularly strong just above the bridge where there was heavy mist. Stronger colour was used to emphasize the crisp edges in the centre when the paper was almost dry. The blue 'windows' in the top corners were also painted in just before drying was completed.

The sparkling surface of the water gave me a fine opportunity for some bold drybrush technique.

△ *Below the Black Mount, Rannoch Moor, Argyll*
15 × 21in (38 × 51cm)

With towering clouds dwarfing the mountains and the bend in the river shimmering beneath the high sun this *contre jour* subject presents the Highlands at their most dramatic.

As usual I began the painting with a wet-in-wet sky using my normal blue-grey mixture, plus yellow ochre and cobalt blue. The essential thing was to retain pure white paper for the tendrils of cloud in the middle so that a blaze of light would be created to set the mood for the whole painting. It had been raining. All the vegetation was wet and shining. This entailed a great deal of preparatory work with a pen and masking medium so that the sparkle of countless highlights could be protected. As well as the glittering water with its drybrush texture the whole foreground, grasses and heather alike, shimmers with light, especially the grassy knoll on the inside of the bend of the stream. Having overpainted this initially I later scraped off most of the pigment with a knife to get the effect I wanted.

Rannoch Moor, leading to Glencoe, is a large, bleak area of moorland, bog and many tiny lochans. In winter, in bad visibility, it can be a death trap. However, for me it is a magical place. Like Glencoe I go back to it time and time again. The figure is a topical focal point.

SUNRISE AND SUNSET

Psychologically, warm colours are very appealing. If I were determined to sell every painting immediately I would put an evening sky into every picture. The appeal never fails. Through the years there have been many painters who concentrated on this time of day. Indeed, Turner's last twenty years or so reveal painting after painting done in the evening. Even if they weren't he would still put in an evening sky. He must have used pounds of yellow, which he called the 'noble' colour. Winter is the time when sunsets are most colourful, and sunrise can be just as bright, as the next painting shows.

△ *Winter Dawn, Bradbourne Mill Farm 22 × 15in (56 × 38cm)*

This sky, though colourful, is a simple one. Extremely gaudy sunsets may cause gasps of delight but they should be avoided by painters. As I know to my cost they usually look cheap and sensational. It is better to settle for a simple evening sky rather than the more vivid sunset.

The feature that particularly caught my eye was the brilliant reflection in the stream and the flooded, rutted track. Notice how the branches above the horizon catch the warm rays of the sun the nearer they are to the sun itself. Naturally that part of a tree which is below the skyline cannot be affected by this glow. I put in the horses because the empty area of snow called out for them to balance the composition.

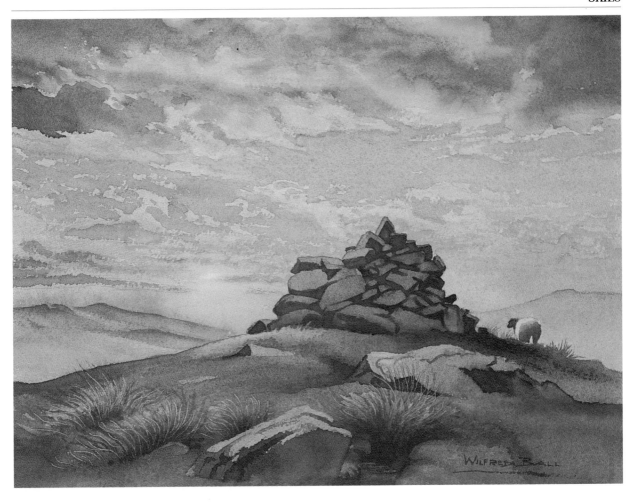

△ *The Lost Lad Pile, Derwent Moor, Derbyshire*
15 × 11in (38 × 28cm)

The cloud formation is a little more detailed in this subject but is rescued from overindulgence by Turner's 'noble' colour, which I deliberately chose because of the subject matter. Early this century, before the village of Derwent was drowned beneath the waters of the Derwent dam, a young boy drove his flock from the village up onto the high moor and was caught in a blizzard. He must have decided to stay with his sheep because three or four days later searchers found his frozen body. Scratched on a boulder nearby was his lonely epitaph – 'lost lad'. The villagers, much affected by the sadness of his end, piled up these stones in a cairn to commemorate the event. A small plaque has since been affixed to it. On every Ordnance Survey map of the area it is clearly marked 'Lost Lad Pile'. Many a monarch has been remembered less graciously.

Whilst composing this painting I bore in mind that it was essential to transform the unremarkable subject matter to make it worth a second look. I was painting the legend rather than the landscape and some kind of transformation was essential.

I felt that a majestic sky would provide a necessary background to the simple subject, which needed to be enhanced in this way to convey truly the dignity of the romantic sad story.

Another thing to beware of with sunsets is the tendency of objects to be silhouetted against an evening sky. The 'cut-out' shapes would destroy any painting. I avoid this effect by sketching or photographing the landscape at least an hour before the sun sets. This allows you to capture the details and tone values before the light goes, then you can add the sunset sky to it. Surprisingly, this relates quite accurately to the real visual experience. Because the human eye is such a sensitive machine it can see details even at dusk when the camera is blind – except with a long exposure, of course.

Above all, keep sunsets simple. You will find that bright red is likely to look vulgar if used together with detailed cloud formations.

Evening Light on High Barth Farm, Dentdale
22 × 15in (56 × 38cm)

Another interesting farm. Typical of old Cumbrian
farmhouses, this has the sturdy circular chimney
stacks that are peculiar to the county. The subject
was made more interesting when the flock of sheep
crossed the foreground, adding another horizontal
emphasis to that of the buildings. It did no harm
either, that the washing was still hanging out. That
sort of local colour is a bonus. The nostalgic
atmosphere was further augmented by the hazy,
romantic blue of the background hills. Again it is a
simple sky. The warm colour is enough without lots
of cloud detail.

WATER

The great fascination water holds for us derives from its versatility – it can vary from still limpid pools to a rushing torrent. It can be of considerable assistance in composition – reflections providing both repetition and harmonies. The colour of the sky being reflected in a stream or pool has produced equilibrium in many a composition. Here follow a few of the different forms that water takes, with observations on the techniques we can use to depict them.

STILL WATER – MIRROR IMAGE

When the surface is as smooth as a looking-glass you will get a perfect mirror image. I avoid painting mirror images. Perfection can be very boring. I prefer my beauty with a little imperfection to add piquancy. The second painting is as near to a mirror image as I'm ever likely to tackle from choice. Even there, the reflections of trees on the left are lost in the darker shadows.

WILFRED BALL

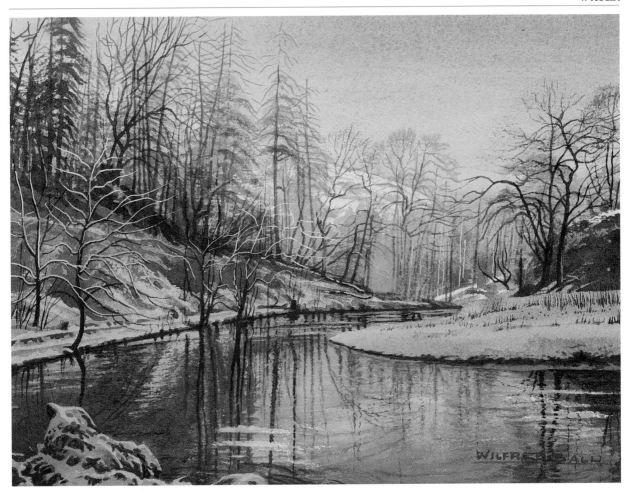

△ *Reflected Gold, Dovedale 15 × 11in (38 × 28cm)*
This is a fine example of a very striking phenomenon, a colourful reflection within a shadow. The contrast makes the colour seem much more intense and vibrant than if the rest of the water were sunlit, too. Here, the blue of shadowed snow is the perfect contrast for the warm gold reflection.

◁ *Spring Morning in Dydon Wood 15 × 11in (38 × 28cm)*
Here the mirror image is not crystal-clear because it is fractured slightly by the gently flowing water and also broken up by the mossy stones in the stream. After protecting the flowers and twigs with masking medium, I painted over the whole picture surface wet-in-wet. First I touched in the bluebells and the blue reflection from the sky in the foreground. Then I washed in the varied spring greens and browns which covered the rest of the picture surface. I came away from the wood with a memory of a saturation of greens glowing in sunlight.

The line of the stream leads your eye into the distance. To prevent this becoming an aimless journey I put in the deer for the eye to settle upon.

Paddling at Upper Slaughter COTSWOLDS

BROKEN WATER – BROKEN REFLECTIONS

Currents create ripples, the breeze dimples the surface. Water is rarely still, reflections are rarely unbroken. Here are two examples which delight in that fact.

△ *The Esk in Springtime 22 × 15in (56 × 38cm)*
Unlike the subtleties of the previous example these reflections are simply broken by the long horizontal streaks of sunshine and shadow. The trees were painted wet-in-wet, some crisper detail being added after the general foliage was dry. Note the pure yellow of the tree behind the bridge to create the maximum contrast with the shadowed bridge.

△ *September Morning, Fairbrook Valley, Kinder Scout 30 × 22in (76 × 56cm)*

Fairbrook is the perfect name for such a perfect mountain stream. For two miles it runs down from Kinder Scout into the River Ashop and thus into the Ladybower Reservoir – another beautiful name – and every inch is a delight.

I went to the valley especially at this time of year because I wanted to capture the early autumn colours before the heather had gone well past its best. But the thing that really captured my interest was the water. The pool was still enough to see through to the sandy bottom, yet the ripples caught the reflection of the blue sky. The contrast between this beautiful blue and the warm earth colours became my main interest in the painting.

As this is a full Imperial-sized picture I had to be aware of a special problem. What might be a quiet little space or corner in a smaller work is inclined to look very empty when it is as big as this. Accordingly I decided to put a flock of sheep coming down the slope at top left, planning to make it reasonably unobtrusive, as it would not do for the corners to compete with the central area. A most important rule of composition!

A very large painting – and a detailed one at that – calls for a lot of careful preparation. It took the best part of a day to treat the delicate details with masking medium, beginning with the tiny sheep on the hillside. After putting textural detail on the heather and highlights on the tree foliage, I dealt similarly with the long grasses down by the water. But the water was always likely to be the most challenging technically. I painted the resist over the blue shapes so that I could deal more easily with the sand and pebbles on the bottom. The birch itself needed the bright edges of trunk and branches protecting also, as well as the backs of the sheep and some of the bracken fronds on the slope on the right as well as bottom left, below the heather.

The sky was painted wet-in-wet, the small triangle of blue on the right being strengthened to emphasize the sunlit slope next to it. On the left I washed in the hillside in pale blue-grey, then immediately touched in a brushful of pale yellow ochre, top left, to simulate the sun streaming across. When it had dried, the stronger blues on the right of the slope were put in. After rubbing off the masking medium I painted in the tiny accents on the sheep and the three figures. At first these darks looked too

obtrusive so I washed clear water over everything and blotted a little of the colour off. Now you only see the sheep if you're looking for them.

Although the bank of heather was all in the shadow it was important to make it recede, so I painted in a mixture of alizarin crimson and cobalt blue, starting at the top and strengthening the colour as it came nearer. While it was still damp I touched a little pale yellow ochre into the furthest heather to simulate the sun-faded colour of heather a little past its best. The shadows between the tufts were put in with a warm green mixture of sap green and alizarin crimson. When this was dry it was strengthened, particularly in the foreground, with a robust mixture of ultramarine blue and alizarin crimson. These same dark mixtures were used for the shadowed bank below the heather as well as its dark reflection in the water.

The painting of the trees and slopes on the right was fairly straightforward, plenty of yellow ochre being used with the colours to keep the overall sunny effect. The birch trunks were painted first with a blue-grey, then the dark markings were put in with the sap green, crimson mixture. Finally the darker markings and strong shadows were emphasized with an even stronger blue-grey mixture. Except for the water, I then rubbed off the masking medium from the rest and finished those details off with the delicate tints required. Finally the four sheep on the foreground bank were treated, quite unobtrusively.

▷ *Enlarged Section of 'September Morning, Fairbrook Valley'*

This enlargement of the water area allows for a more careful study of the techniques used to produce this magical pattern. You will be able to see that when the pale blue areas were covered with masking medium, as were the surface bubbles on the left created by the splashing of the waterfall, it was quite easy to take a large wash brush and put in the warm, sandy colours of the stream bed. I used yellow ochre, raw sienna and burnt sienna in broad washes right across the masking medium. After this had dried I took a thinner brush to put in the dark edges and shadows of the stones and small pebbles on the bottom. Then I finished off with a darker grey wash between the blue ripples left of centre and towards the bottom of the painting. When everything had dried thoroughly I rubbed off the masking medium and put a pale blue wash over the uncovered shapes.

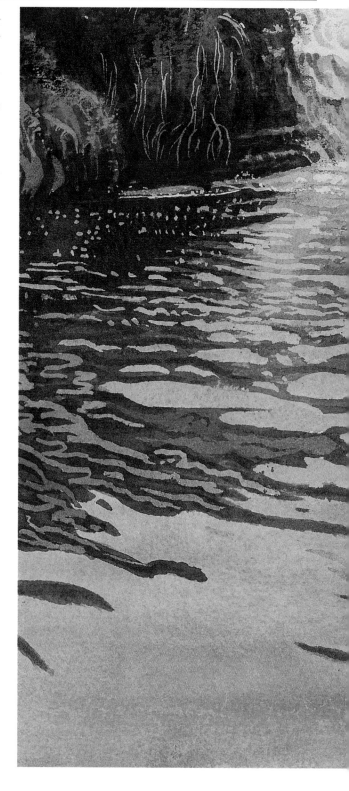

Initially this phenomenon looked as if it would be extremely difficult to paint, but the careful use of masking medium removed all the problems. I think you will agree that the final effect looks both delightful and natural. It reminds me of countless happy hours as a child spent lying face down on just such a grassy bank searching for freshwater crayfish under submerged stones like these.

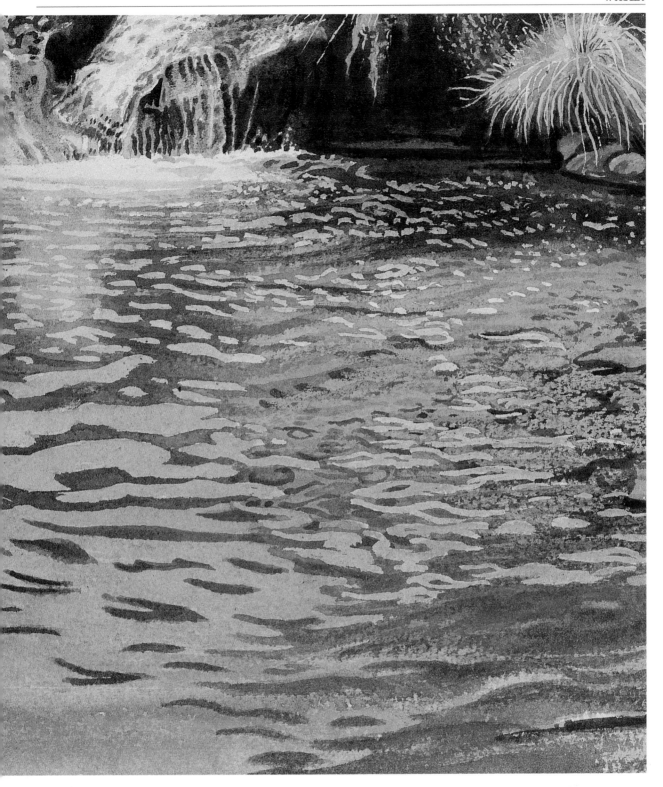

SPARKLING SURFACES – DRYBRUSH TECHNIQUES

Bright light on broken surfaces produces a glitter which is both attractive and dramatic. Typical surfaces of this kind are wet scree slopes, choppy water, or wet foliage. If a full brush is used the pigment will flood the area, so it is important to use a charged brush that has been pressed hard against the side of the mixing tray to take off a good deal of the liquid. Hence the term drybrush. The mixture used needs to be a comparatively strong one to emphasize the contrast with the untouched white of the paper which produces the sparkling effect.

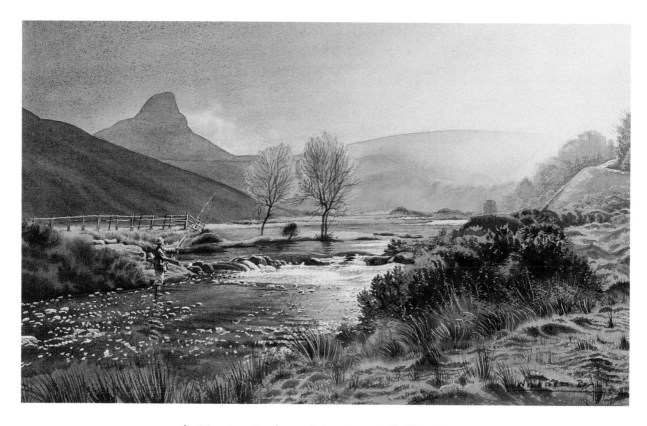

△ *Morning Sunburst below Stac Pollaidh, Wester Ross 22 × 15in (56 × 38cm)*
Compared with the painting opposite, sparkle here is much more subdued. It is helped by the tiny, gleaming wet stones in the foreground. The effect of the sunburst was created by painting in the sky and background then dropping yellow ochre into the wet wash on the right and tilting the paper to encourage it to flow to the left.

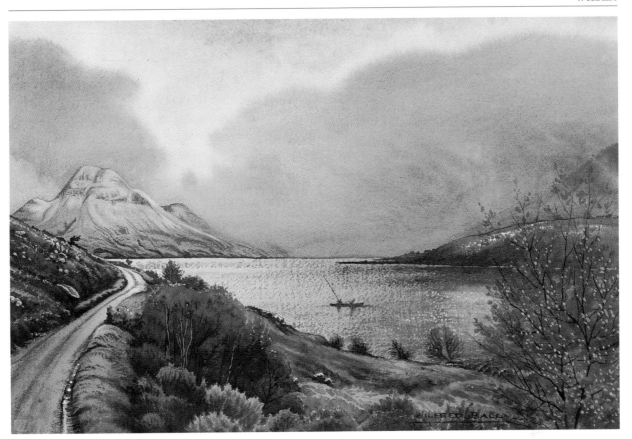

△ *Morning Light on Loch Lurgainn, Inverpolly*
22 × 15in (56 × 38cm)

The new snow on Cul Beag is here muted by the shadow cast by the warm morning clouds, just parting to admit the sun. On the right the faint low cloud is being lifted on the thermals in flickering wraith-like fingers reaching up to the sun whose warmth would dissipate them all too quickly. This effect was produced by brushing wavy strokes of clean water into the cloud wash just before it was dry. If I'd introduced it while the cloud was still wet it would have dissipated and disappeared into the background colour with only the faintest trace. Below the sunny gap the water was painted a creamy yellow before the blue-grey sparkle could be dragged across it when it had dried.

You can only use a drybrush technique if you are using paper with a rough surface. Here I used a flat, chisel edged brush dragged across the paper while held at an angle of about thirty degrees to the surface. While the pigment catches the top of the most prominent textures it skips over the rest without touching it. It is a method perfectly suited to produce the sparkling effect of bright sunlight on choppy water.

WHITE WATER – CATARACTS

Rapids, cataracts and waterfalls produce a great deal of sparkling foam and spray, and such broken water is often described as white water. Where the areas of white are sizeable, it is important to put in sufficient detail, faint though it may have to be, to explain the structure of the moving water. Otherwise you will have a series of empty, white holes in the picture. This third painting is a good example.

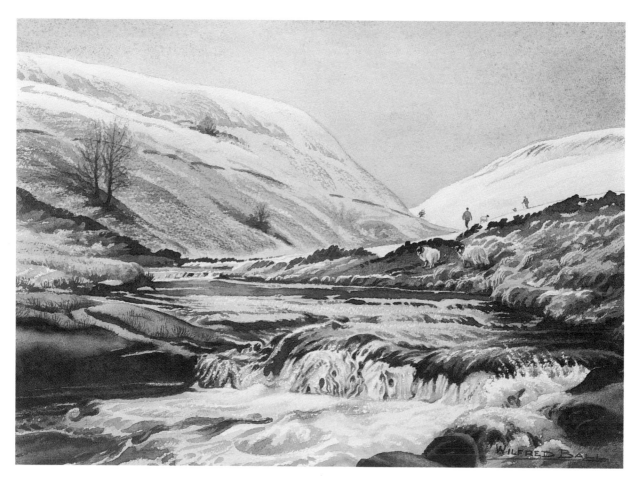

△ *Shepherds, Derwentdale, Derbyshire 15 × 11in (38 × 28cm)*
This very wintry scene is typical of the wild, bare dale north of the Derwent dam. Artistically it provides another interesting example of counterchange at the point where the warm sky separates the slopes of the hills to the right, shadowed and sunlit respectively. The heavy tones of the water are made to look even colder by the green of the broken water in the foreground.

In the middle, the still, undisturbed stretch, which is reflecting the warmth of dead bracken on the hillside above it, is very important in providing a variety of colour and texture to the surface. The tiny figures were placed to achieve maximum impact considering their size and the painting gives a striking indication of the lonely, bare places where many shepherds have to tend their flocks. The warm colour in the sky which is reflected onto the sunlit snow of the hill on the right is most important as a foil to the otherwise chilly scene.

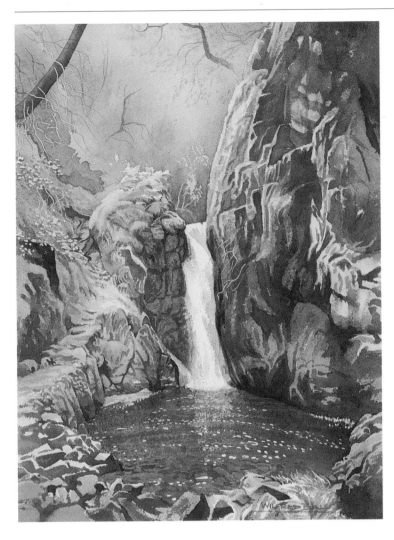

△ *Stanley Force, Eskdale 11 × 15in (28 × 38cm)*

This fine waterfall hides up a narrow glen only walking distance from the terminus of the Ravenglass/Eskdale Railway, so popular with tourists. The weight of the white water crashing down decorates the swirling pool with a necklace of winking bubbles as in the next painting. It is a beautiful walk up to the fall, especially when the spring flowers are at their best.

Rocks and White Water, Dunnerdale 22 × 15in (56 × 38cm) (Overleaf)

This fine stretch of broken water is only a few paces above Birks Bridge, the most photographed spot in Dunnerdale. Before painting it I protected the bubbles on the dark pools to the right with masking medium. I began by damping the paper in the water area and modelling the white water with delicate touches of pale blue and blue-grey. Although pure white paper had to be retained it was important to give enough definition to the masses of rough water to explain its movement. When this had dried I used drybrush strokes of stronger colour to emphasize it. The pools were painted with a strong blue-grey mixture with browns and greens touched in to indicate the reflections from the rocks.

The plantation in the background was painted wet-in-wet to make it keep its distance. The rest was just a matter of concentrating on the sculptural and textural qualities of the great rocks, emphasized by the strong shadows. Their sunlit brown tones stressed their warmth compared with the cool blues and greens of the rushing water.

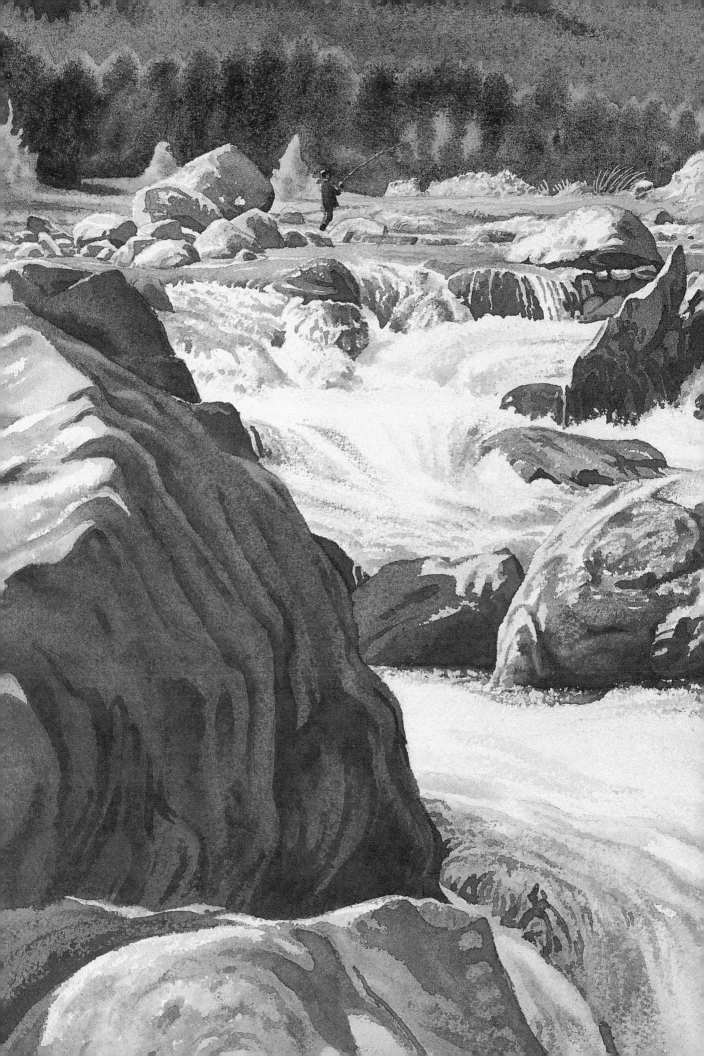

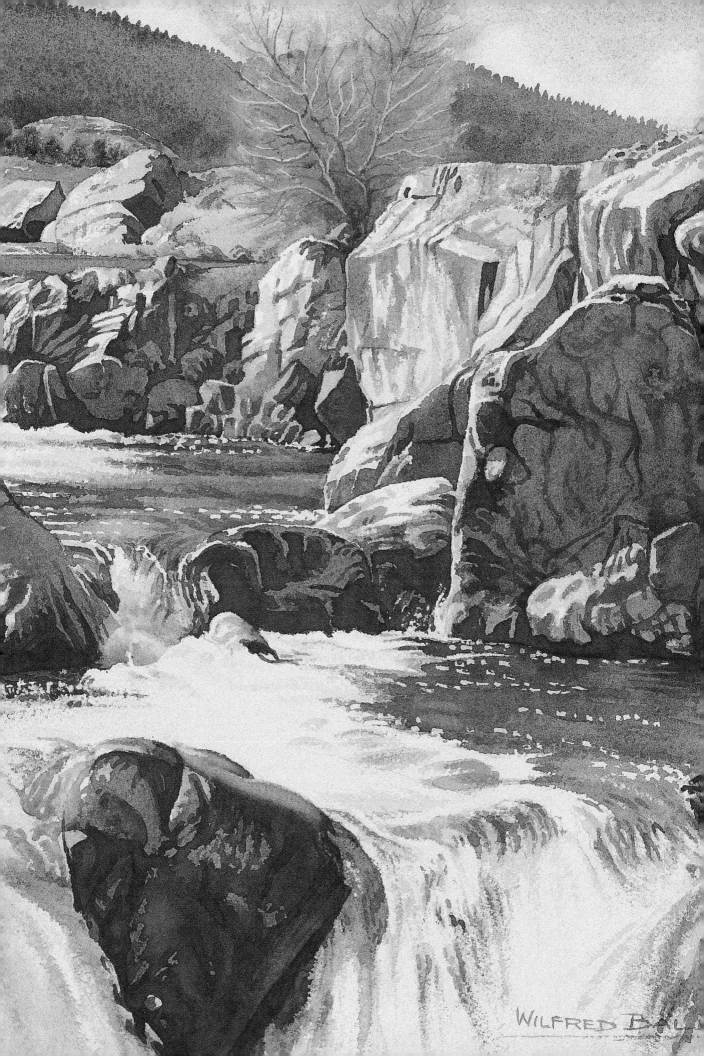

WILFRED B...

RAIN – WET SURFACES AS HIGHLIGHTS

Water or slick wet surfaces are a godsend in dull conditions when a composition might otherwise present little variety of tone. I often introduce pools of rainwater on paths for that reason. In bright conditions however, such highlights can produce a jewel-like sparkle which is most attractive.

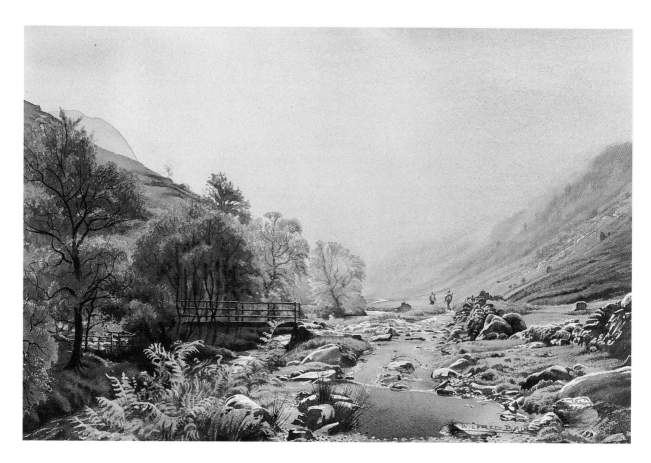

△ *Sunshine after Rain, Langstrath, Borrowdale*
22 × 15in (56 × 38cm)

It is always a magical moment when the creamy sun pierces the pearly mist after a period of rain. Here the wet edges of stones in the path and on the tumbledown wall shine silver in the saturated foreground. Down the slope to the right tumbles the thin thread of a stream in spate, details of which were covered with masking medium before I began painting.

The composition revolves round the bend in Langstrath Beck where the tree, its autumn foliage beautifully backlit, glows against the misted fells which fade into the distance. Autumn colours can look vulgar and garish if a painting is full of them. When placed amongst the subtleties of translucent grey mists they are shown to their greatest advantage. The richness of the sunlit bracken is enhanced by the pearly greys in the wet path.

△ *Above Kinder Downfall, Derbyshire*
15 × 11in (38 × 28cm)

Kinder Downfall is one of the most spectacular natural phenomena in Derbyshire. As the waters of the Kinder River fall off the edge of the high plateau into a prevailing southwesterly breeze they are picked up and thrown back more than fifty yards beyond the point where they originally fell into space. This curtain of spray leaves the rocks along the Downfall slick and shiny. On the occasion I have illustrated, the wind dropped enough for me to approach without getting drenched. However, the breeze was still fresh enough to flick the surface of the stream into gleaming ripples, adding their sparkle to the sheen of the stones.

Without these highlights this would have proved a sombre and unremarkable subject. As it is, there is a real shimmer about it.

The Coach & Horses, Derwent Edge

THE SEA

Spending most of my time among the high moorlands and fells as I do, the sea does not figure in my output very often. However, its fascination outlives time and the archetypal memories of seaside holidays come flooding back with the slightest encouragement.

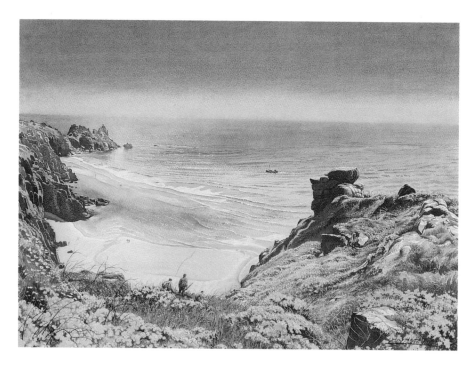

△ *Clifftop Flowers, Porthcurno, Cornwall*
30 × 22in (76 × 56cm)

As this was a full Imperial painting the large stretch of sky was more than usually daunting. I might well have painted it as a flat wash, unusually, but that would have given it a clarity and transparency that the heat haze was veiling. As a result I decided that a wet-in-wet treatment would best avoid any crispness and so I sponged the whole of the sky area with clear water down to the band of sea mist that was masking the horizon. Having mixed a little crimson into cobalt to produce a warm blue, I brushed the mixture across the sky area with broad strokes of a wide brush. The brush I used was the two-inch-wide pastry brush I have described earlier, which is a godsend when painting large areas. The resultant hazy effect was just what I had been trying for.

The sea area was painted next but as I've had it enlarged for the next colour plate a description of that process will have to wait for the moment. It is worthwhile noting the treatment of the cliffs, however, as they provide an excellent example of how to create recession. See how the local colour,

faint browns and greens, fades gradually as the eye moves towards Logan Rock in the distance. These tones not only become paler but bluer as the planes edge away from us.

Having protected the detail in the foreground by masking medium, I was able to tackle it with a large brush and broad washes of background colour – greens, yellows and browns – which I could strengthen in places, while they were still wet, with touches of much stronger mixtures. These broad washes served to preserve the unity of the area which would have otherwise been threatened by the multiplicity of tiny detail.

Fortunately the great clumps of gorse covered enough of the area to hold things together quite well and they were put in with bold patches of yellow ochre and cadmium yellow. Although not so dominant, the pinks and blues were repeated often enough to produce a rhythm of colour that also was unifying. You will notice that I used the bluebells predominantly for this purpose, sweeping in a hooked curve of hazy blue from the rocks on the right and across the base of the painting.

Now I was able to rub off the masking medium,

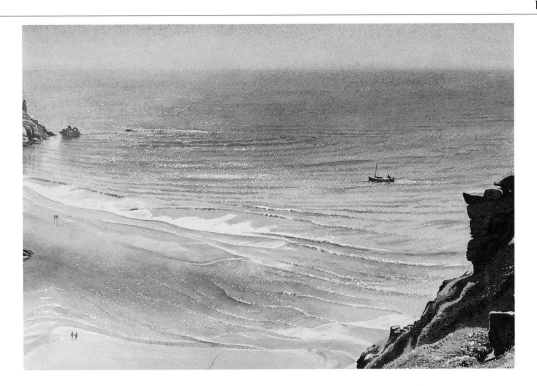

giving full value to the bank of white dog-daisies on the left. The painting was finished by tinting in the delicate colours of the blooms which had been uncovered by the removal of the masking medium.

△ *Enlarged Section of 'Clifftop Flowers, Porthcurno'*
In spite of the bright flowers it was the sea that really entranced me in this subject. Although it was relatively calm its surface was covered with little flecks of light that rose and fell on the swells, flickering in and out like stars. The obvious way to treat it was by drybrush work but this effect was so delicately charming that I felt it would not do justice to it. In the end I settled for putting in every point of light individually with a pen and masking medium. Personally I think the final result justified the time taken. It also enabled me to produce the same kind of sparkle along the curving rhythms of the waves and breakers as they approached the beach.

The sand itself was a challenge in subtlety. It was treated with delicate washes of yellow ochre, raw sienna and burnt sienna. I even used cadmium orange for the tiny piece of submerged sand on the extreme left. To produce the effect of damp sand affected by the incoming waves I added a little pale cobalt blue to burnt sienna.

There were two main problems in painting the sea itself: firstly, the subtly changing colours and secondly, ensuring that the perspective of the receding lines of waves was accurate. Once more I used the two-inch flat pastry brush I had used for the sky.

I mixed in advance copious amounts of the following mixtures: cobalt blue with a little crimson, cobalt blue with a little winsor green, and pure cobalt. This would enable me to move from one tint to another without being held up in any way and allow the washes to merge with one another where required. After damping the hazy area of the horizon I swept a full brush of the greenish mixture across the horizon then carried it down over the rest of the sea, missing out the white edges of the breakers. I then returned to the skyline, passing a wash of the warm mixture, blue and crimson, across it, to merge with the first wash, for a distance of three or four inches below the horizon.

When the wash had begun to dry I took a smaller brush and put in the darker rhythms of the waves with stronger mixtures of the same colours touched into the damp background. This treatment emphasized the perspective of the waves I'd been aiming for. Rubbing off the myriad dots of masking medium then left just the hazy sparkle I had sought. The method had enabled me to keep a more deft control of the delicate effect than if I had used drybrush.

The tiny figures of the bathers down on the beach were touched in with a shade of burnt sienna. As so often happens when the edges are occupied by dominant shapes, the centre of the composition looked empty. It didn't take long to draw in the small fishing boat but I had to put in the figures of the three anglers clambering down the middle slopes before I felt more satisfied with the result.

4

FROST AND SNOW

Of all the phenomena which affect the appearance of the landscape, none is so dramatic as hoar frost or snow. Frost deposits a thin, brittle crust of sparkling white on every delicate detail, isolating each individual blade of grass. Everything open to it is completely transformed but not hidden. Snow, on the other hand, provides nature with a disguise. The coating of snow varies in thickness, covers more completely, rounds off sharp or irregular shapes and hides all detail. It muffles both sound and appearance. I think I love painting snow scenes more than anything.

Frosty Ride 20 × 15in (51 × 38cm)
What a delight to come upon this huntsman walking the hounds, his hunting pink the only colour in a steely landscape. The metallic clatter of the horse's hooves on the echoing road only served to emphasize the iron grip of the frost.

In order to create the effect of individual grasses coated with frost I put in a series of pen strokes with masking medium, simulating this in the foreground. The only other concession to frostiness apart from the generally muted colour scheme was the cool blue I put into the wet wash of pale ochre and umber I painted for the dead grasses.

Compare this painting with 'Frosty Morning, Scotchergill' (page 64), a painting which required a completely different approach.

HOAR FROST

In bright conditions hoar frost can produce a fairyland – sparkling and pristine. An excellent example can be seen in 'Heavy Frost, Hayridge Farm' (page 65). When the frost is light, it is sufficient to isolate details with masking medium – a texture of individual blades of frost-covered grass or of white-dusted twigs and branches. The painting 'Frosty Ride' tackles this problem economically but effectively.

△ *Frosty Morning, Edale, Derbyshire 18 × 11in (45 × 28cm)*

A really thick hoar frost like this produces a fairyland. Every tree was thickly rimed as if it were a Christmas decoration.

As you can see I had to spend a long time with a pen and masking medium before painting commenced. To emphasize the frosty twigs a dark background was essential. The cold, clammy mist over Lose Hill helped but I needed to darken it even more before I was satisfied with the effect, which was heightened by the stretch of sunlit grass across the centre of the composition.

When the picture was finished and the masking medium rubbed off I found the foreground did not look frosty enough, so I scraped off some of the green pigment with a knife.

△ *Frosty Morning, Scotchergill, Dentdale 22 × 15in (56 × 38cm)*

This is one of the most difficult paintings I've ever tackled because of problems with colour. As the sun had crept higher and higher above the horizon it had transformed the chilly blue landscape into a golden wonderland that took your breath away. It was not until later, when I sat down in the studio to design the painting that I realized the pitfalls.

First of all, it was top-heavy. Originally there were no sheep and the whole foreground except the wall was pale-blue frosted grass. I couldn't cast a shadow across the bottom to balance it because the shadow was already there, and being cast on a light surface it couldn't realistically be made darker. Even the dark wall and the damp patch of earth at the bottom right were not going to be enough. In any case there was the problem of colour. The top of the painting would consist of rich warm colours, even though the dark shadows beneath the trees were very blue as they were protecting unmelted frost, while most of the foreground would be a cold greenish blue.

As the foreground also needed added interest to compete with the trees and the buildings above, the obvious solution was to add some warm colours in the shape of animals or hens. The sunny patch of grass in the centre where the sun had crept through

a gap between buildings and walls to banish the frost was the obvious place to put them. I decided on the local sheep because the sunlight on them would enable me to enrich their already creamy fleeces. The red stains on them also helped. Of course the boy's sweater had to be red. Put your hand over him and see how the painting would look without him. In the search for even more warm colours I emphasized the drift of dead leaves at the foot of the wall. And all this had to be decided and drawn in before I could start to paint.

As usual there were a few details to be put in with masking medium. The sunlit twigs on the left and then the roofs and chimneys on the farmhouse as well as the tops of the walls and white gate in front of the buildings. Finally dozens of short pen strokes isolated the frosted blades of short grass.

Confident that my preparation had been meticulous I couldn't wait to begin painting, the treatment of the grass being the crucial problem. Apart from the sunny patch and two long streaks of white below it I washed pale blue over the whole foreground, strengthening it in the deeply shadowed hollows in the centre. Warmer colours were touched into the damp wash in the bottom right corner for stones, dead leaves and the damp earth. The rich, dark yet warm colour of the pool was put in after the wash had dried. I used a blue-green for textural details on

the grass, emphasizing some of the clumps with a brownish green later, before I used the same colour for the shadowed stones of the wall on which I also left patches of blue for the frosty traces. A yellower green was used for the sunny grass in the centre.

Finally the strong cast shadows were put in with a blue-grey mixture.

When all this was dry and I rubbed off the masking medium I felt pleased with the final effect of crisp, brittle grasses.

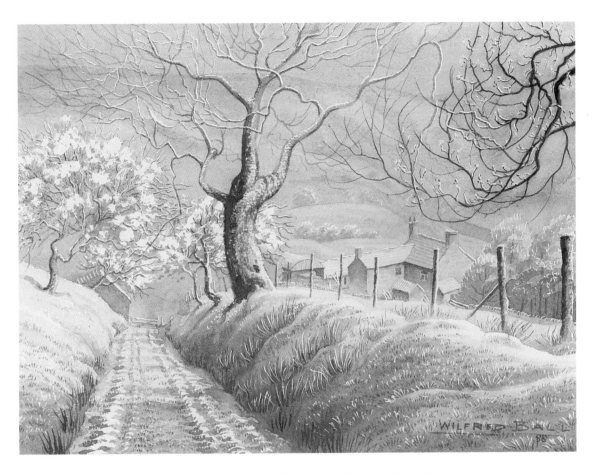

△ *Heavy Frost, Hayridge Farm, Woodlands Valley, Derbyshire 15 × 11in (38 × 28cm)*

I don't think I have ever seen a heavier frost. The temperature stayed below freezing all day and this hazy blue frosted atmosphere remained unchanged for several days. The grassy track is the old Roman road up to the Snake Pass.

The sun-warmed haze was achieved by adding a little alizarin crimson into the cobalt blue which I painted in a modulated wash over the whole of the paper after masking the highlights with medium. Further detail was put in with increasingly strong patches of the same blue.

The final touches were washes of diluted yellow ochre on the stone walls of the farm to indicate the weak sunlight. A mixture of blue and burnt umber was used for the accents on the nearer trunks and branches and the fence posts. But the overriding effect is of the blue monochrome beauty of that marvellous morning.

SNOWFALL

I am surprised that so few painters tackle this archetypal phenomenon, which really does have a magical quality. One sees plenty of paintings of fallen snow but hardly ever do they show snow actually falling. The techniques involved are a little tricky but I cannot believe that other artists find snowfall uninteresting. An easy way of representing snowflakes might appear to be to put spots of masking medium irregularly over the picture surface before painting, but having tried it I can assure you that the result is quite unsatisfactory, being far too precise to simulate the fluffiness of the flakes.

The following paintings show two techniques I have found successful in producing the soft-edged effect required.

△ *Backpackers on Malham Moor, Yorkshire*
11 × 11in (28 × 28cm)

I learned this technique from studying American watercolourists, many of whom use it. It consists of sprinkling crystals of sea salt onto washes of damp colour. In the drying process each crystal rejects the pigment in its immediate vicinity, leaving a pale but not completely white soft-edged shape quite like a snowflake.

Disappearing into the swirling blur of a snowstorm these backpackers, on their way along Mastiles Lane towards Kilnsey, head into oblivion. A little flourish of the wrist as the particles of salt are released creates a flurry reminiscent of a storm-tossed snowfall. The wash into which they were scattered in this case was a pale mixture of cobalt blue and burnt sienna with a brushful of yellow in the top left corner indicating the sun trying to break through. Just before the salt was sprinkled I put in the walls with a stronger colour. The figures were put in after the paper had dried.

If the paper is streaming wet when the salt is applied it will disperse with almost no trace. To get the kind of effect achieved here the paper must have dried a little but still show the faint glisten of moisture which indicates that it is not yet completely dry. Try it. It's a little difficult to control but no other method produces results which are so vigorously expressive.

The hunched figures express their discomfort by their body language as they disappear into the blizzard, their enormous packs transforming each of them into Quasimodo.

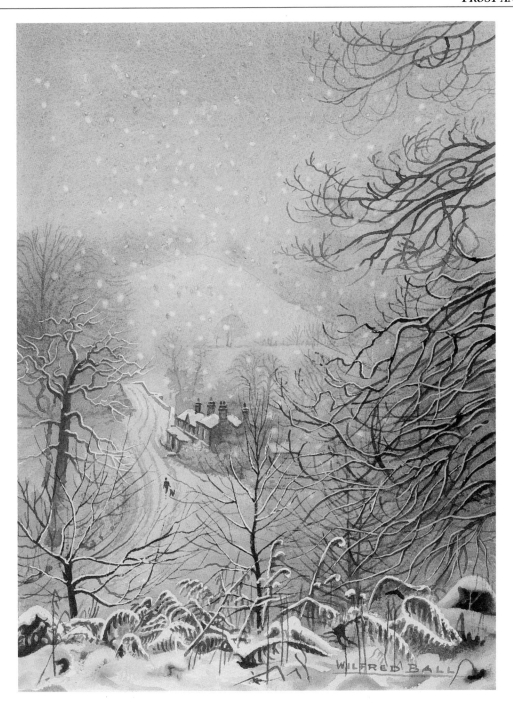

Snowfall at Chatsworth, Derbyshire 11 × 15in (28 × 38cm)

Looking down through the trees onto the stone bridge which is the southern entrance to Chatsworth Park I could see the soft flakes drifting slowly down the heavy sky. A sombre yet subtle subject.

I began by putting in masking medium for the foreground detail, branches, dead bracken, the snow-capped walls of the bridge and the roofs. On a dampened paper I brushed in a wash of blue-grey, made colder on the left and warmed with a little burnt sienna on the right. When it had dried to the stage where I sprinkled the salt on in the previous painting, I then removed the pigment from the paper in the spots where I wanted the snowflakes. This I did with a brush handle wrapped in an old handkerchief. When dabbed onto the damp paper repeatedly it will lift off just enough pigment to produce the faint markings shown here. The rest of the painting was completed after the surface had dried.

An alternative but slightly more tedious process which produces similar results is to finish the painting, then remove the individual snowflakes with a small, damp hoghair brush and blotting paper.

COLD/WARM LIGHT ON SNOW

I've always loved painting snowscenes but couldn't understand at first why I couldn't sell some of them very easily. Because I went out looking for subjects on sunny winter days the blue sky was reflected everywhere in the shadows and I was producing almost pure blue monochromes. As I've mentioned before, people have a psychological resistance to cold colour schemes and an equally strong liking for warm colours. I know enough about the problem now to warm the sunlit snow with a creamy yellow and to introduce warmly coloured elements such as tree trunks, dead leaves and grasses, and animals to give the cold blues a run for their money.

Look at the Impressionists. They invariably painted snow in the evening, the warm light tinting it with pinks and lilacs, as sweet as sugared almonds. That's what I usually do these days, as the third of the following subjects will show.

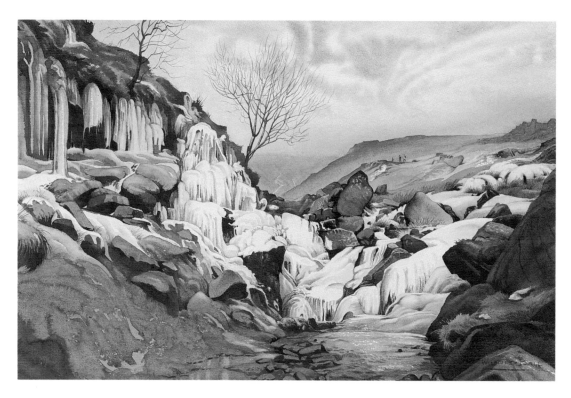

△ *Icicles beside Grindsbrook Clough, Kinder Scout, Edale 28 × 19in (71 × 48cm)*

The tiny figures are on the first mile of the Pennine Way from Edale. It was a difficult subject. As the sky discloses, the sun was shining but could hardly pierce the clammy mist that cloaked Kinder Scout and it clung to the recesses of the clough. As a result the foreground snow and ice were not at their most colourful. However, everything was saved when the occasional passage of sunshine filtered through onto the slopes of glowing rusty bracken, as here. One of the solutions to cold colour schemes therefore is to paint a thaw, when part of the landscape is not covered and you can make the most of its colour.

My first intention was to paint the giant icicles – some were eight feet long – pendant from the overhangs, but there seemed no way I could produce a good composition with them in a central position so I dismissed them to the sidelines and focused on the snow, the tumble of rocks and the bracken.

As can easily be seen I painted the sky completely on damp paper but the rest was done almost all on dry paper because of the need to control the detail of the complex formations of snow and ice.

The translucence of ice means that it is quite different to paint from snow. It has greenish tints which make it look colder than snow, which indeed it is. Because it was overcast there was not a great deal of tonal contrast and sparkle in the snow, but it is interesting to observe the places where the melting snow had frozen into ice.

▽ *A Sprinkle of Snow on Scafell Pike 22 × 15in (56 × 38cm)*

One way of solving the problem of cold colours in snow scenes is to go to the mountains, as here. Now the blues can perform their natural function of creating the effect of recession while the warmer advancing colours can occupy the foreground. It is both a scientifically and artistically satisfying solution. The foreground positively leaps out at you.

Nature is not always so obliging but in this case she cleverly avoided the division into entirely cold colours in the upper half and warm earthy colours in the lower. Because the lower slopes of the mountains are only thinly sprinkled with snow, I could drag raw umber with a dry brush up the slopes to indicate the dead grasses which are peeping through the snow. This breaks down a little the complete dominance of cold colour. In the same way the ice-cold blue of the water in the foreground creates a contrast of colour temperature between the rocks and the ochres and umbers of the grasses alongside.

If you know the mountains you are painting it is possible to experiment with the placing of light and shadow in the interests of a better composition. In this case I felt that the gleam of light along the top of Cam Spout Crag on the left was important, surrounded as it was by shadows. Similarly the brilliantly lit snowfield on the right leads the eye nicely upwards and out of the painting. The focal point, the sunlit area on top of Esk Buttress in the centre was carefully surrounded by shadow then emphasized by the strong dark above and behind it. This prevented the eye from wandering about looking for a focus. It was important for it to have somewhere definite to come to rest.

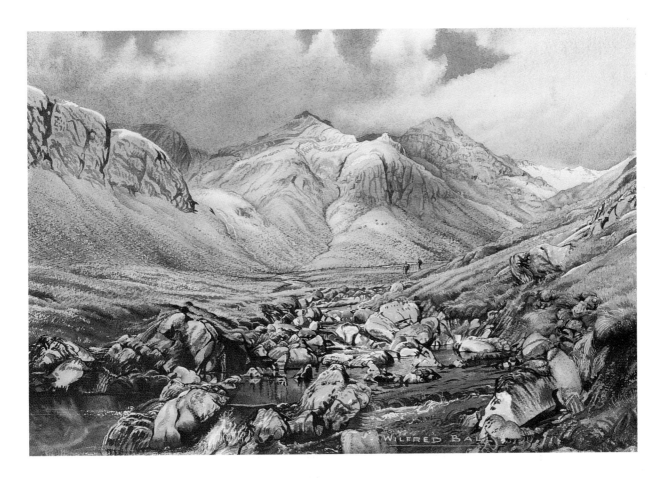

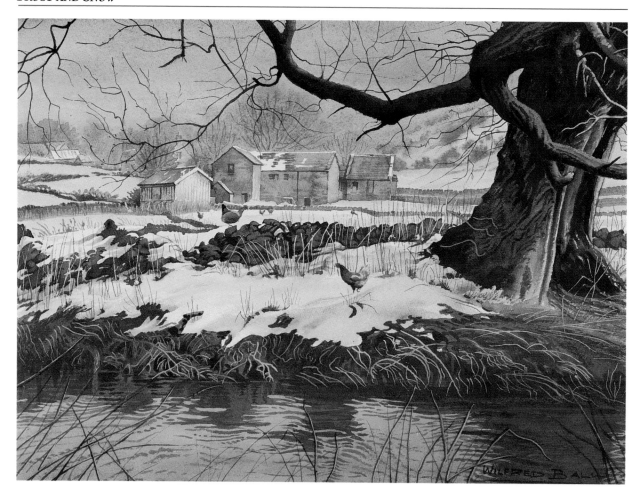

△ *Winterglow, Bradbourne Mill Farm, Derbyshire*
15 × 11in (38 × 28cm)

The third and most successful way of overcoming the psychological resistance to predominantly cold colour schemes in snowscapes is to paint warm ones. Winter mornings and evenings produce the most glorious warm skies and since snow reflects the sky you can see an endless variety of pale tints of yellow, rose pink, carmine, mauve and lilac.

I have pulled out all the stops in this painting to demonstrate the possibilities of warming up a snow painting. We have a lovely rosy sky, warm trees, red tiles on the roof, mellow stone buildings, brown hens and even water to reflect the rubicund sky. The tiny accents of faint green in the roof of the henhouse, the small door in the barn and on the lower bark of the large tree serve by simultaneous contrast to make their surroundings look even warmer.

Of course, it is unnecessary to use *all* these devices to achieve your aim. Usually just a warm sky will suffice.

5

MIST

Misty conditions are beloved of poets and painters because they give rise to such evocative effects. These can range from delicate, shy suggestions of half-hidden beauty, both of shape and colour, to heavier, more ominous possibilities of menace. In autumn, a full range of bright foliage hues can be overwhelming and cool mist can then be used to mute these rioting colours and introduce an element of delicacy and counterpoint into the colour scheme.

POETIC/ATMOSPHERIC

We tend to attribute human characteristics and moods to aspects of the weather. Warm, cool, stormy, thunderous all have human connotations, for example. Mist tends to conjure up words such as atmospheric, poetic and mysterious, these associations extending not only into painting but into poetry, literature and music. In a more practical sense it is a tool that the painter can use to emphasize the elements of depth and recession in a landscape. Obscuring the detail makes it more obvious which objects are further away in the distance than others, as well as emphasizing atmospheric perspective – the way in which things look fainter as they recede.

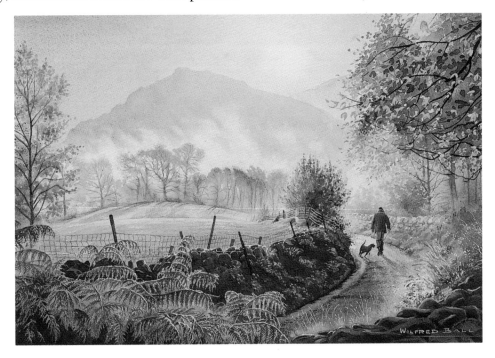

△ *Sunlit Mist, Eskdale 22 × 15in (56 × 38cm)*
On my way along the track to Penny Hill Farm one October morning I was confronted by this seductive sight. Harter Fell was beginning to show through the mist and below it the valley was filled with cold, clammy banks of low-lying vapour. As the sun climbed above the fell it pierced the mist with a creamy glow that completely transformed it and gilded the trees before it. I had never before seen mist backlit and translucent like this.

Before beginning to paint I took a pen and masking medium and drew in the gleaming fence wires and delicate seedheads in the foreground to preserve the backlit detail for the final stages. After wetting the top half of the paper I washed some pale yellow ochre into the sky and mist followed by cobalt blue in the top corners. I was careful to leave the white glow of the sun untouched. When this was dry I put in the mountain with pale blue, stronger on the left, fainter and creamier on the right near the sun. While it was still damp I drew a brush of clear water into its lower edge to create the shapes of the upper tendrils. Pushing the medium before it the clear water was successful in producing these diffuse, delicate edges.

I put in the trees and the glowing foliage above the lane in pure yellow to ensure the necessary sunny glow, before indicating the distant trunks and branches with a warm grey mixture – burnt sienna plus blue. Notice the importance of the dark bush and the figure in emphasizing the sunburst at the bend in the track. The rest was completed in my usual logical progression from light to dark. I was delighted with the way the seedheads in the right-hand foreground glowed against the shadowed track.

This painting is a good example of the evocative and magical effects that sun and mist can conspire to produce.

▷ *Misty Stream, Holymoorside, Derbyshire*
15 × 20in (38 × 51cm)

The mist here gives emphasis to the romantic, poetic possibilities of the subject. Technically it is a clear example of the uses of masking medium for simplifying a subject with a multiplicity of detail. Note the sunlit foliage, the fronds of bracken and the fallen leaves in the foreground. The faint trees in the background were put in while the sky was still damp so as to keep them soft-edged.

This painting proved something of a disappointment. I was inspired originally by the beautiful glow of light through the backlit foliage but the final result falls far short of what I had hoped for. Perhaps the background tints are too pale to emphasize the yellows. The result is pleasant enough but has not really captured the excitement of the original brilliance of the backlit leaves.

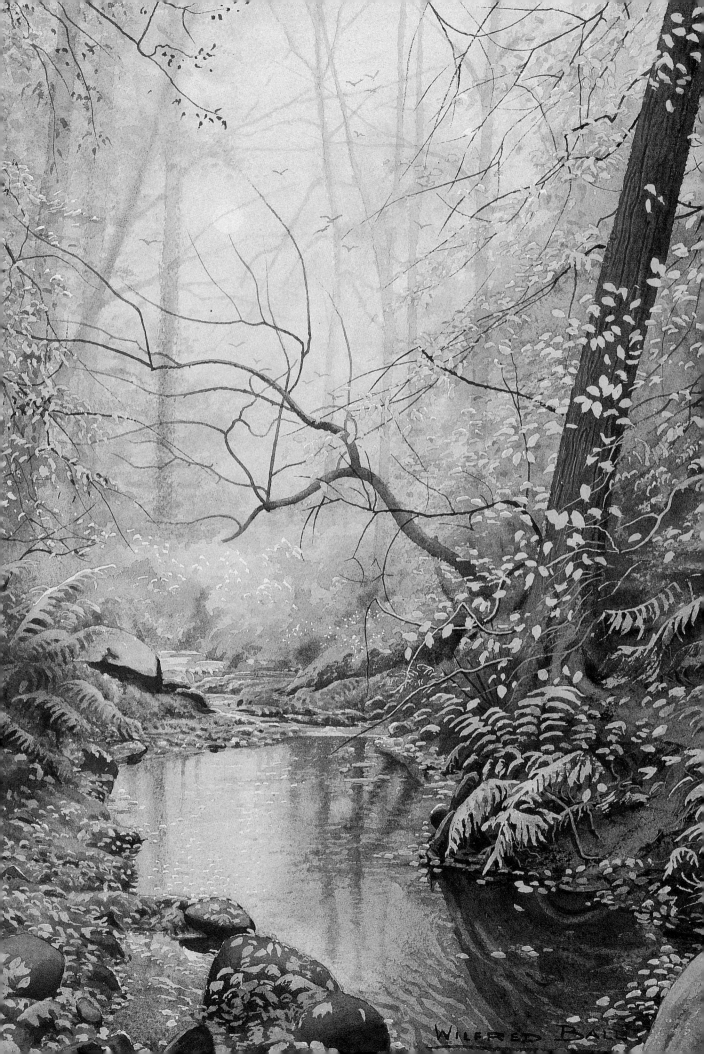

WILFRED BALL

EMPHASIZING RECESSION

As well as its potential for creating an interesting atmosphere, mist serves an equally valuable function in emphasizing depth and recession. By masking details it simplifies the basic shape of objects and adds to the effect of atmospheric perspective, as the following paintings demonstrate.

▷ *Winter Sun on Kinder Scout 15 × 11in (38 × 28cm)*
The morning mist having been almost dismissed by the sun, it was now more of a faint haze. None the less it had produced a clear progression of tone between foreground, middle distance and distance. Note the delicate, pearly tints of the background hill. The common perception of winter as a cold, grey phenomenon is vigorously dismissed by this combination of dead bracken, heather and warm moorland grasses.

A common error in painting patches of snow in the distance is to leave areas of untouched paper to represent them. The atmosphere between the viewer and the distant snow will reduce its clarity as it does with all other distant colours. In this painting

I wet the distant area first and then put in cobalt blue at the top, gradually adding weak burnt sienna to create the hazy effect lower down. Before it dried this wash was too dark to look like snow. However, when it had dried I used mixtures of the same two colours to strengthen the slopes of the hill, leaving the unmelted snow patches untouched. Although not pure white they clearly represent snow. This is a useful demonstration of the transformation of familiar objects and colours by atmospheric perspective.

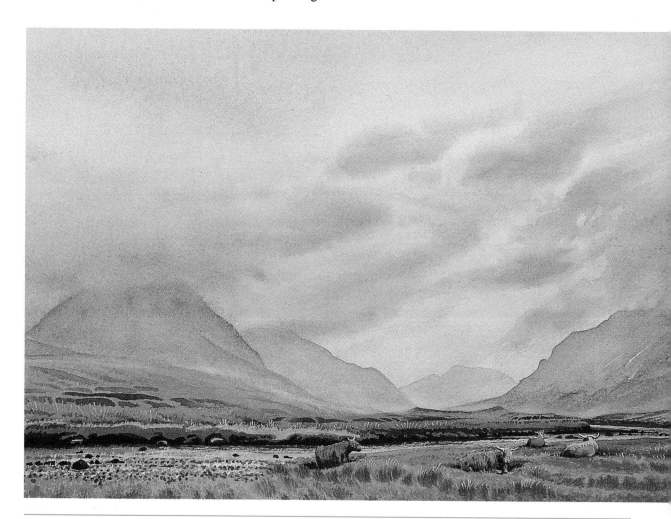

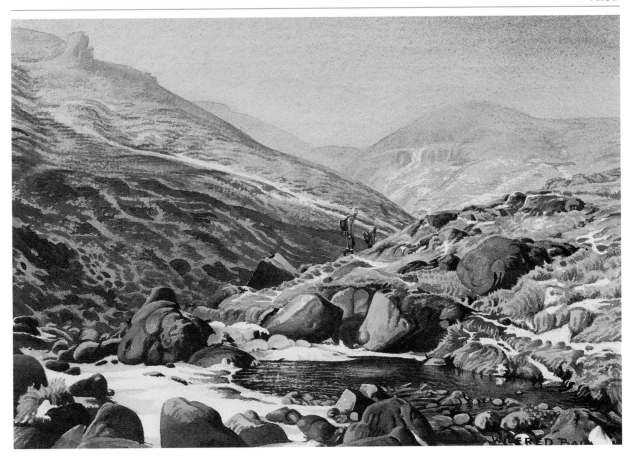

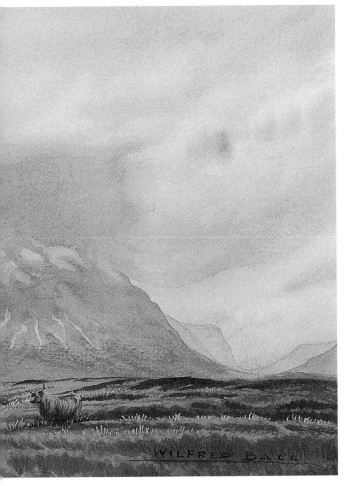

◁ *Approaching Glencoe, Rannoch Moor, Argyll*
22 × 10in (56 × 25cm)

This is another reminder of the rich colour of moorland grasses in winter, much of the foreground being painted in almost pure burnt sienna. This colour, of course, is emphasized by the late afternoon sun's warm colours low down in the sky being reflected onto it.

The pools of white mist lying at the foot of each mountain can be produced, as in this example, by washing out a little pigment with clear water and a damp hoghair brush. This subject gives a very clear demonstration of the way mist emphasizes recession. The effect is shown most instructively by the three mountains on the left as they fade into the distance.

This painting also shows vividly another characteristic of low cloud in mountainous regions, that of clinging to the peaks. Here the tops are obliterated by cloud, yet there are clear gaps in between them. The phenomenon is most clearly demonstrated by Buachaille Etive Beag on the right, whose cloud cover mounts high into the sky while other cloud, from the left, is being attracted to it as if by a magnet. The entire sky was painted wet-in-wet.

ATMOSPHERIC PHENOMENA ASSOCIATED WITH MOUNTAINS

The last painting leads most naturally into this chapter. I spend so much time in the high country – it is my favourite subject matter – that I hope you will forgive me if I devote a whole chapter to the delights that mountains regularly afford me.

'THOSE BLUE REMEMBERED HILLS'

Those of you who share my memory of Dennis Potter's television play about childhood under the above title, will no doubt agree with me that the quotation is as evocative of youthful hopes and dreams and past delights as any ever written.

'Ingleborough Evening' (below) is very much in that mood of golden days and evenings that seemed never to end. In each of the following group of paintings, the distant hills are indeed blue, in the literal as well as the poetic sense.

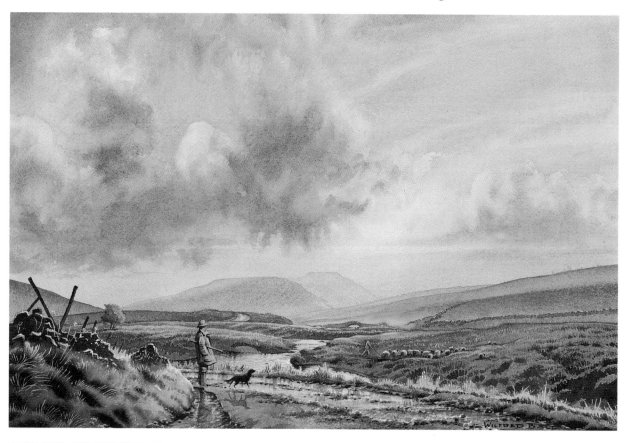

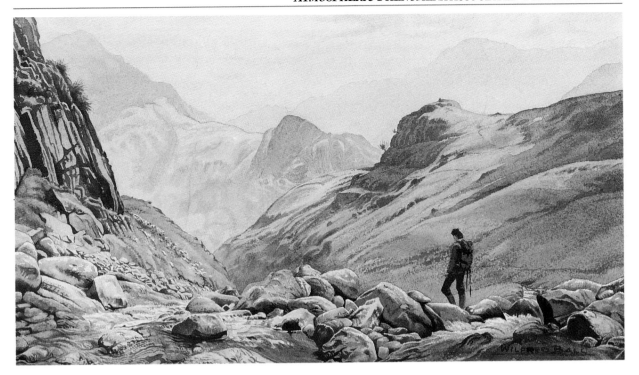

Ingleborough Evening 22 × 15in (56 × 38cm)
(Below left)
As you will observe elsewhere in this book, Yorkshire Dales landscapes are usually constructed of muted greens and greys, so this colourful scene is far from typical. We were driving down Ribblesdale and suddenly rounded a bend to see this unexpected delight, the whalebacked bulk of Ingleborough mountain, powder blue beneath a cloudscape of peach and gold. Not only because of its colour does it merit being included under the poetically evocative heading above. Because the sun was still relatively high it was able to bathe the autumnal moorland in a rich golden light, gilding the stream alongside the road and complementing the blue hill.

This is a fine opportunity to demonstrate the painting of a complex cloudscape. Note the flat cloud base of the more distant clouds on the right and the rounder and more irregular base of the nearest ones left and centre as they piled up above our heads. After wetting the sky area I tinted it with pale cadmium red at the top and yellow ochre below leaving a glow of untouched paper just above and to the right of the mountain, to indicate the source of the light. I then brushed in stronger pinks and oranges mixed from the same two colours onto the cloud formations. Finally I mixed a warm grey by adding the red to cobalt before putting in the darker forms on the clouds. I further strengthened these just before the paper was dry. I painted a little cadmium yellow into the clouds on either side to emphasize the rich golden quality of the light there.

When the wet-in-wet washes had dried I laid in a graduated wash of cobalt, beginning at top left and becoming weaker to the right and below. This wash enabled me to delineate the warm shapes of the clouds, softening their edges with a damp brush where the outlines were too hard. These are my normal procedures when painting complex cloudscapes.

The wet road surface enabled me to paint in a satisfying reflection from the alert young dog.

Side Pike and Harrison Stickle from Stickle Beck, Great Langdale 20 × 11in (51 × 28cm) (Above)
This blue haze on a hot day in May has exemplified the effects of atmospheric perspective. From the dense blue shadow of Harrison Stickle to the middle values of Side Pike in the centre and on to the dimly seen shape of Wetherlam on the right the effect of relative distances is greatly emphasized by the hazy atmosphere. In dealing with this I painted from the distance, making sure that the colours were extremely weak and warmed with a little pink, and adding more blue to this mixture as I moved forward. Not until I reached the slopes below Harrison Stickle did I introduce any additional colour, in this case a weak green. The dark figure was a late addition, specifically to emphasize the tonal perspective which is the technical theme of this painting.

△ *Morning in Buttermere Village 22 × 15in*
(56 × 38cm)

Another fine example of atmospheric perspective, the faint blue of the distant mountains to the left strengthening as we look over to the right where we begin to see detail for the first time on the wooded slopes, beautifully lit by the creamy light from the sun, which is just beginning to break through the misty haze. This effect was what most appealed to me about the subject. The strongly backlit trees and buildings in the foreground further help to emphasize the delicacy of the tints in the distance. Note the importance of the silvery surface of the lake, seen through the trees in the centre, in widening the range of these faint washes.

I spent a long time painting the rusty reeds and bracken in the foreground. Once more I was thankful for masking medium, without which I could not have retained the complex detail gleaming against the masses of dark undergrowth. The washing on the line and the hens and chickens gave a nice nostalgic feel to the domestic quality of the subject.

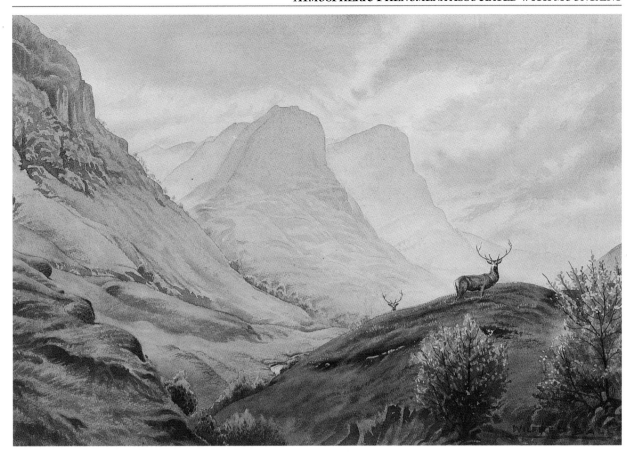

△ Stag in Glencoe, Argyll 22 × 15in (56 × 38cm)
Blued off against the golden evening sky the Three Sisters loomed over the misty recesses of this famous glen. There was snow to come. The red deer do not venture as low as this until they know snow is about to cover the mountain tops. This is another example of atmospheric perspective, the furthest mountain having been painted in a pale blue wash with no added detail, stronger tones of blue-grey being used on the other two mountains to create the detail which brings them forward. To mirror the evening light I covered the whole painting with pale yellow ochre to begin with, so the blue mountain is not really pure blue but is greyed off by the yellow glowing through it.

The two nearer mountains were treated with a blue-grey wash all over at first, then the yellow green was touched in while it was still damp, as a background to the detail on the lower slopes. This helped to hold these advancing colours back in the distance in a satisfyingly credible way. Atmospherically this little device worked perfectly. While the paper was still damp I strengthened the darker detail on the mountain slopes with more of the blue-grey mixture slightly strengthened.

The cold evening mist was beginning to fill the hollows below me at the bottom of the glen where the gilded stream still reflected the sky dimly. I simulated this effect by brushing cobalt blue into these recesses and allowing the colour to run into the warm greens and browns on the slopes just above them. I had to be careful not to obliterate the sloping file of distant trees whose sun-touched tops still stood above the mist. The same was true of the foreground trees, only the topmost branches of which were tiptoeing into the last light of the sun.

You will observe the rich, dark colours with which I painted the foreground. Both the warmth of the colour and the strength of tone were essential to create the atmospheric recession I had planned. A few minutes later, the sinking sun had left nothing but dark silhouettes, instead of misty magic.

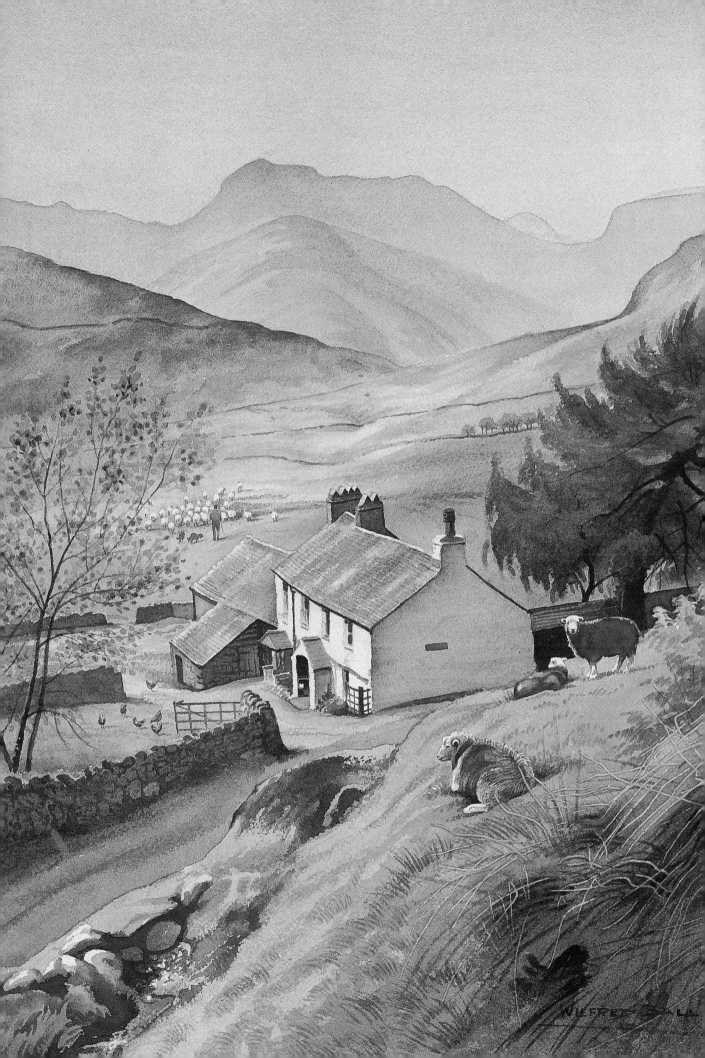

◁ *Bowfell from Bleatarn House, Langdale 15 × 20in (38 × 51cm)*

I have painted this view many times but never had I seen the mountain look so blue, the ridge running down from the peak being well lit from the south and so strongly sculpted in light and shadow. The beautifully situated farm makes a fine foreground.

Note the detailed paintings of the Herdwick sheep. With their wiry, grey wool dusted with red dye, their white faces and legs are very strong features. No other sheep create such a sense of place, for they are to be found only in the Lake District.

△ *Suilven from Inverkirkaig, Wester Ross 22 × 15in (56 × 38cm)*

Suilven is my favourite Scottish mountain, perhaps because its shape is so immediately recognized. On this day, having climbed the slopes above Inverkirkaig Falls especially to reach this viewpoint, I felt more than usually exhilarated. The sun shone on its first dusting of snow, while the heavy low cloud behind might have been placed there specially to show it off. I must confess that when I came to paint it I strengthened the dark tones even more so as to emphasize the magical mountain.

For once it is interesting to look at the atmospheric perspective I have demonstrated in painting the ground rather than the hills. The richness of the grasses pales as the eye passes over them into the distance, gradually blueing off into greys. Another note of great visual excitement was provided by the foreground pool, set like a jewel among the rust and russet tussocks. Its intense blue reflects the sky high above it and I can assure you I did not exaggerate the colour in any way.

I don't think I've ever enjoyed painting a mountain subject more than I enjoyed this one. Pure pleasure!

HILL FOG

One of the disadvantages of spending a lot of time amongst mountains is the tendency for hill fog to descend on you without warning. Apart from wetting you with clammy drizzle it cuts visibility down to a few feet at times. For a walker it is unpleasant, but for an artist it is a disaster. What he can't see, he can't paint. When the visibility is not so severely reduced, however, it can produce very paintable atmospheric effects, as the following paintings demonstrate.

△ *Quinag Under Cloud, Sutherland*
22 × 15in (56 × 38cm)

The road to Kylescu passes close to the old drovers' road just north of these rocky outposts of Quinag. Through the clinging mist the bedraggled back-packers appeared. Somehow they completed such a characteristic scene that I couldn't resist the challenge. Coming upon the lovely old bridge completed the composition and I probably wouldn't have painted the subject without it.

The sky was painted wet-in-wet, a little diluted yellow ochre being introduced into the blue-grey to show the watery light on the right. While it was still wet I drew my brush diagonally across it to simulate the mist drifting across the face of the mountain buttresses. When this was dry I painted the mountains in slightly stronger greys, with the lower slopes delineated fairly clearly but the crests disappearing into the low cloud. I achieved this effect by softening the top edges with a brush dampened with clear water which I drew into the damp wash to create the faint tendrils drifting down.

A fleeting passage of creamy sunlight on the bridge produced a welcome variety of lighting into the scene.

△ *The Black Mount under Cloud, Rannoch Moor, Argyll 22 × 15in (56 × 38cm)*

This mellow evening light is much easier to handle than the gaudier effects of an outright sunset. Here the last golden light pierces the low cloud to produce a marvellous combination of silvery greys and russets. The reflected glow in the golden stream makes an eye-catching focus for the composition. Against it and emphasizing it, I very carefully placed the figure of the angler.

The sky was painted in my usual wet-in-wet procedure, the pale blues being added when it was dry, so as to show up selected cloud shapes more precisely. While the yellows were mixed as usual from yellow ochre I used a little cadmium orange for the burnished stream and the central glow in the sky. The foreground was completed almost entirely in burnt sienna, with a little dull green in places and a strong grey for the dense shadows.

HIGH AND LOW CLOUD ON MOUNTAINS

One of the most remarkable atmospheric phenomena in high places is the way the cloud can hide the tops of mountains one day and the next day the peaks gleam in the sun while the lower slopes are shrouded in cloud. I have already commented on this habit that clouds have of making a beeline for the tops of mountains, and I have also shown mountains standing in pools of mist.

On rarer occasions, tendrils of horizontal cloud can be seen drifting across the flanks of mountains, half-way up. The next painting delicately demonstrates this, while the later ones show some of the other eccentric behaviour of cloud in mountain areas.

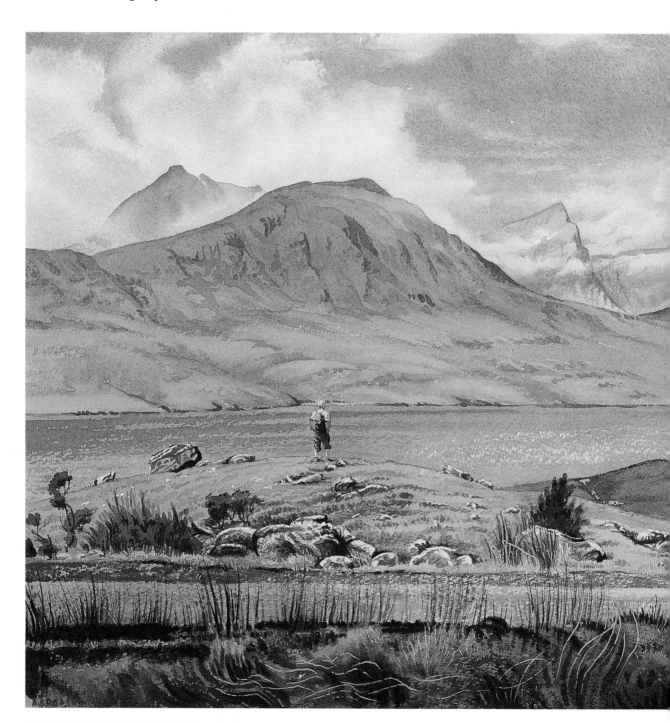

▽ *Cloud across the Fiddler, Coigach, Wester Ross*
22 × 15in (56 × 38cm)

This is the sort of balmy day that shows off mountains at their best. Plenty of sunlight but enough cloud to throw moving shadows across the scene. These shadows are very handy for altering one's composition at will, for they can be moved about with no loss of verisimilitude.

Here the horizontal skeins of fluffy cloud break the sharp shadow down the sheer edge of the Fiddler most attractively. It is a quite simple procedure to wash out such tendrils with clear water and an old bristle brush after the mountain has been painted. For me the other interesting aspect of the composition was the lively clockwise swirl of the higher cloud, which adds movement to an otherwise static horizontal composition.

△ *Cloud on Stac Pollaidh, Wester Ross*
22 × 15in (56 × 38cm)

I spied this striking cloud effect just before it lifted off the craggy ridge of this bristling little mountain. It gives a fine demonstration of how low cloud like this can cast quite dramatic shadows onto an otherwise sunlit mountain. Here the lifting cloud still clings like a leech to its weakening grip on the dark peak. The sky was painted entirely wet-in-wet, even the windows of cerulean blue sky. I chose cerulean instead of my usual cobalt because it is a cooler tint and emphasizes slightly more the warmth of the morning clouds. Their basic pale grey had a little crimson added to achieve this warmth and together with the cool blue it gave the crisp freshness one often finds in morning skies.

In this subject there is little opportunity for perspective because one cannot see into the distance, so I chose to emphasize the effect of the brooding shape looming above me. Note the rounded patches of lichen on the foreground boulder, details which emphasize its nearness compared with the more distant stones.

Cloud over Loch Hourn 22 × 10in (56 × 25cm)

Loch Hourn is one of Scotland's most remote sea lochs and its surroundings are impressively rugged and mountainous. This panoramic view enables us to see clearly the way clouds arrange themselves in horizontal strata. Because of the amount of detail I had to work on dry paper most of the time, after an initial brief stage of wet-in-wet. As a result I had to use a damp brush to soften many edges. Distant clouds will never display crisp edges because of the faint veil of atmosphere we look through. As the most distant mountains are many miles away this painting is another good example of atmospheric perspective. Notice how the strong, heather-rich colours in the foreground fade gradually into the fainter, bluer tints of the far distance.

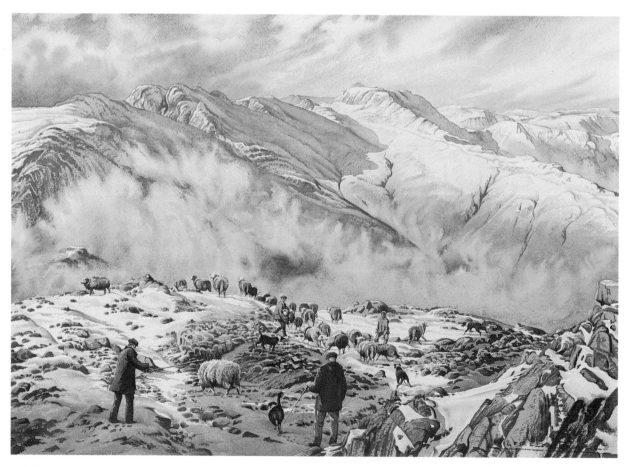

Low Cloud, Bowfell from Pike O'Blisco, Langdale
22 × 15in (56 × 38cm)

The tops of Crinkle Crags and Bowfell, covered in snow, were gripped by an iron-hard frost all day, in spite of the bright sunlight. Below the snowline I could see the faint bracken-covered lower slopes warming in the sun. But the whole of the floor of the dale was obliterated by a sea of cold, clammy cloud. In order to pursue the metaphor of iron hardness I painted the snowy passages on dry paper with lots of precise rocky shapes and crisp shadow edges, while as a contrast the sky was painted entirely wet-in-wet, as was the low cloud. The upper tendrils of the latter were produced by touching in clear water which pushed into the blue pigment of the snow shadows while they were still damp, creating the characteristic cottonwool edges.

Concentrating on the low cloud, I observed how cold and dark it looked, low down on the right, where it was below the direct rays of the sun. On the top left, however, the sun was shining through it, glowing against the shadowed mountainside. The warmth of the light even produced tints of a peachy hue in this sunlit area. The contrast between hard and soft is what produces the artistic tension in the painting.

The detailed complexity, particularly in the foreground, is countered by the simplicity of the colour scheme. Only cobalt blue, yellow ochre and burnt sienna were used, except for a hint of crimson on the sheep to suggest the peculiarly warm grey of the Herdwicks' fleece. These few colours, appearing as they do in all parts of the picture, produce a most pleasing unity of effect in an otherwise 'busy' scene.

HIGH VIEWPOINTS

Standing high on a mountain one can well imagine the seductiveness of Christ's temptation in the wilderness. In a sense the view from a high place transforms each of us into the monarch of all we survey. Added to the intriguing nature of the experience is its rarity. Most people very rarely achieve such high vantage points from which to gaze, so the impact is all the greater.

There follow five paintings of landscapes seen from above at various times of the year, each of which has left a mark on my memory.

▽ *View South from Kylescu, Sutherland*
22 × 10in (56 × 25cm)
Here I looked across the space rather than down into it, but it provided a beguiling panorama. Kylescu Bridge was out of sight below and mountain upon mountain marched into the distance.

The composition was tricky as there was no distinctive feature in the distance to draw the eye, so I introduced the sunlit passage and the bright road near the centre to provide a focal point. On a clear day like this, atmospheric perspective can be at its least obvious but the considerable distances between the mountains easily solved that problem. In the foreground the warmth of the sunlit heather solved this problem of recession conclusively, as well as being attractive in its own right. The heads of the red deer, particularly the fine stag, were introduced to give further emphasis to this difference between foreground and background.

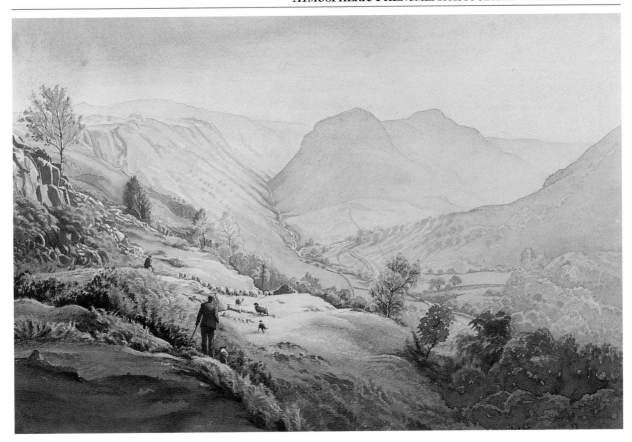

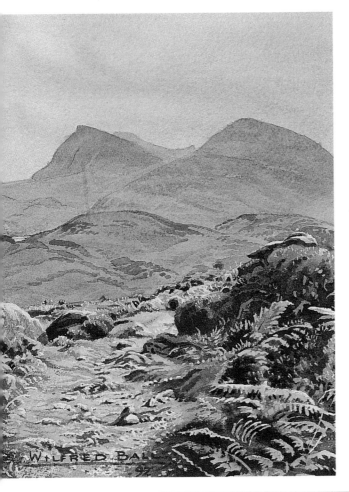

△ *Above Stonethwaite Beck, Borrowdale*
22 × 15in (56 × 38cm)

It was a warm autumn day and from our vantage point high above Stonethwaite the dale was veiled by heat haze. Silvered by the high sun the beck gleamed between the trees, on its way to Derwentwater. The colour was glorious, with rust and gold complemented by the misty blues.

The key to the success of the painting lies in the middle distance. Although the distance was treated in simple washes of pale bluish-grey the painting would have been divided into two obviously distinct halves had I used the same treatment for the middle distance. Although I began with an overall wash of the pale grey I put into it areas of yellowish green and a pale burnt sienna while it was still wet. This not only simulated the effect of sunlit fields glowing through the haze but also avoided too obvious a division of the picture space. The shadowed sides of the trees and other small details were put in with a somewhat stronger blue-grey after these washes had dried. A gradual loss of local colour as the eye moves back through the blue haze achieves the atmospheric perspective at which I had aimed.

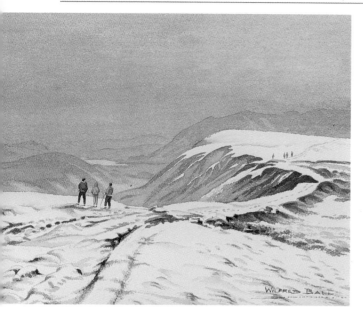

◁ *Lake Bassenthwaite from Maiden Moor*
15 × 11in (38 × 28cm)

The bright anoraks of the walkers are very important in this otherwise monochrome painting. All the time we had clambered from Catbells up onto Maiden Moor the distance had been cloaked in an impenetrable haze. Now a hint of watery sun on the right lifted the faintly gleaming surface of the lake out of the distant murk.

My usual grey mixture was warmed with a little crimson for the basic greys of this composition. It was important for the integrity of the painting to use the same warm grey for the shadows on the snow, reflecting as they do the colour of the sky. Note how I hazed off the lake and sunlit areas of snow in the distance as compared with the crisp whiteness of the sunlit snow on Maiden Moor in the foreground.

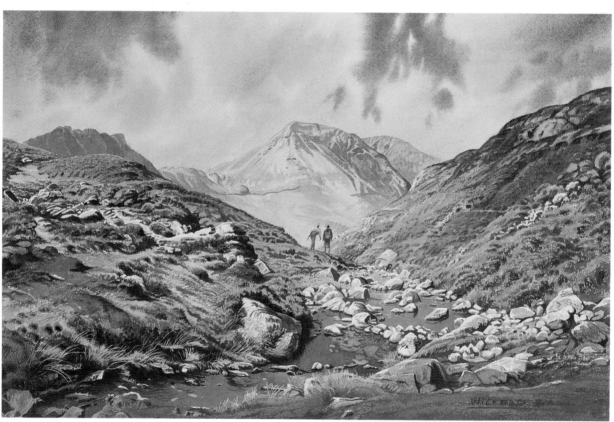

△ *High Stile from Warnscale Beck*
22 × 15in (56 × 38cm)

On the way from Honister to Haystacks this is the first good view one gets of the High Stile ridge. Unlike the viewpoint in 'Above Stonethwaite Beck' (page 89) and 'Above Buttermere in September' (page 126), it does not afford a glimpse of the valley between, with Buttermere and Crummock Water stretching into the distance in the latter to explain the distance separating them. Artistically this created problems. The whole of the heather-carpeted foreground was bathed in sunlight, every boulder and pebble gleaming. There was a complete dichotomy of colour between the top and the bottom, cold blues above, warm tints below.

To overcome this sharp division it was necessary to introduce as many cool colours into the foreground as possible. Firstly I chose a position where I could get the maximum amount of the stream into the composition. Its rich reflection of the

sky solved most of the problem, but not all. I decided to introduce some cloud shadows across the foreground, which would add a good deal of cool grey as well as making the painting more stable by making the base heavier in tone. This arbitrary introduction of shadows cast by clouds can save many a composition – providing of course that you have painted the sort of sky that would cast such shadows.

Note how the verticality of the blue 'windows' in the sky adds an interesting dynamism to what would otherwise have been quite a horizontal composition.

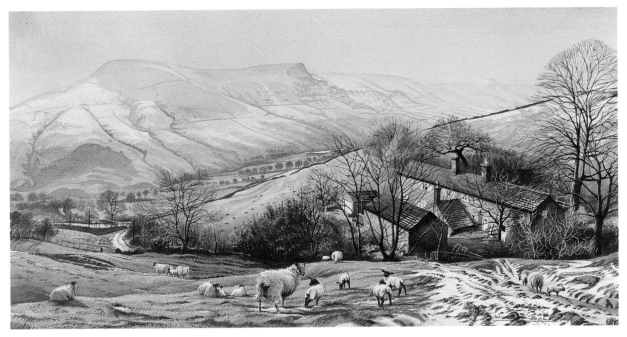

△ *Lose Hill from Clough Farm, Edale*
30 × 15in (76 × 38cm)

High on the grassy slopes below Kinder Scout I looked across to the snowy Lose Hill ridge, where the morning sun was peering through the mist and beginning to light up the ample curves of the buxom slopes.

I began the painting by dampening the upper half and washing in pale blue-grey, warmer on the left, almost pure blue to the right. While it was still wet I put in a wash brush full of yellow ochre, tilting the paper to drift it diagonally across the sky on the left. When this had dried I painted the whole of the ridge in varied tints of the blue-grey, getting fainter towards the right where I washed a little pigment off

the sunlit summit of Mam Tor, light against the mist. The darker details were emphasized with even darker greys. Finally I put in washes of faint greens on the lower slopes and the bottom of the dale where there was no snow. Like the wave of a magic wand the pale blues of the tops were transformed into fields of snow by contrast.

The muted greens of the grassy slopes in the foreground, the rich browns of the sunlit trees and the glowing stone of the farm buildings further emphasized the distant snow. Meanwhile the young lambs indicated clearly the coming of spring, which was further heralded by the patches of melting snow. The landscape is a heart-warming illustration of the calendar of change in the countryside.

CHANGING SEASONS

The gradual change from one season to the next offers regular inspiration to the landscape painter. Personally I can't wait for autumn and winter, my favourite times of the year. In the early part of my painting career I rarely tackled summer subjects, finding the rich greens rather monotonous and uninspiring. The fact that this attitude has changed I owe to my painter friend Rex Preston who encouraged me to focus on the seasonal flowers and plants, whose rich hues combat this monotony. It is to this gaiety that the following group of paintings is dedicated.

SEASONAL FLOWERS

Victorian watercolourists doted on cottage gardens with roses round the door but were rather less interested in the less formal wild flowers. However, the latter provide just as accurate an indication of the annual calendar as the cultivated ones. Also it is remarkable how strong an impact they can make when they grow in close clusters or over a wide area. I particularly recall a trip in April when the grass verges were a continuous delight, so solid were the swathes of dandelions. I captured this effect in 'Dandelions at Arncliffe' (page 94), which clearly demonstrates the riot of colour.

▷ *The Edge of the Wood, Derbyshire*
22 × 15in (56 × 38cm)
Who could resist this great bank of sun-drenched bluebells?

This subject enables me to explain in detail how I set about painting my favourite wild flowers. Firstly the colours. As a rule of thumb I tint all sunlit areas with a warm blue, reserving stronger cooler blues for the patches of shadow. To begin this painting I mixed a wash of cobalt blue with a little crimson added to warm it and painted in the patches of sky and the areas of bluebells. While this was still damp I painted a pale green over all the areas of foliage and grass, bluer in the distance, yellower in the foreground, allowing it to run into the blues a little so as to soften the edges everywhere. The warm overall blue not only created a nice hazy sky but also introduced a unity of colour throughout the painting.

I stressed earlier the importance I attach to the use of a limited palette, but when painting flowers it is necessary that the hues used are true or you can easily lose the essential character of the flower. For painting bluebells I add cobalt violet to my palette.

Added to the cobalt blue it produces the lovely warm colours evident in the foreground blues. Note how I have applied the colour in a series of vertical strokes in order to explain the habit of growth of the flowers. Further emphasis is supplied by the few sunlit bluebells silhouetted against the dark shadow cast by the large tree across the foreground. The bluebells in dense shadow were painted with washes of ultramarine warmed with a little alizarin crimson. You will now realize how many tints and shades of blue I have mixed to create the subtle warm lights and cold shadows, the gradual recession and finally the habit of growth of the bluebells.

Talking of recession, it is even more important than usual in a picture like this, that has no real distance, to make sure that depth is accentuated by any of the little techniques that can be used for such a purpose. To this end I used only shades of blue-grey for the trunks of the trees on the left, which are the most distant, while introducing truer local colours, yellows, greens and browns, into the trunks on the right to bring them closer. Even here, however, I reduced the strength of the dark tones so that they could not vie with the really strong darks I

needed for the shadows on the stately, foreground tree. When painting the latter I used great care to capture the ridges, the crusted excrescences and the mossy stains on its trunk so as to emphasize its importance as the focal point of the composition.

But now for the tricky part! Right from the beginning I knew I was going to have a problem with this subject. Because of the angle of the slope and the shadows on it, the nearest stretch of fencing and even the pronounced lean of the main tree trunk, the whole composition threatened to slide down into the right-hand bottom corner and drag the eye out of the picture space. To counter this I had decided to introduce some strongly shadowed figures in the bottom corner to bring those diagonals to a halt and jerk the eye back from the periphery. In the end I used a horse and rider, judging that it would catch the eye even more forcibly than just figures.

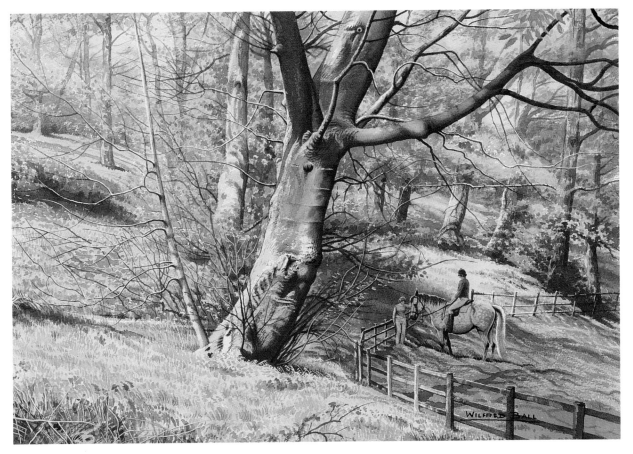

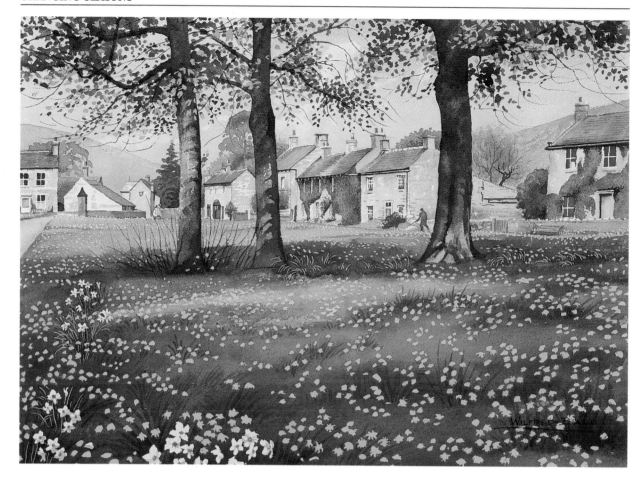

△ *Dandelions at Arncliffe, Littondale, Yorkshire*
22 × 15in (56 × 38cm)

This attractive village was the original setting for the television series *Emmerdale Farm*. When we drove into it one April day the village green was a carpet of gold. The humble dandelion was just as colourful as any cultivated flower and of course far more prolific.

Technically this painting is a *tour de force* for masking medium and its ability to isolate each of the many hundreds of individual flowers. I was careful to treat the fringe of fine stone cottages very simply. Otherwise the painting would have looked extremely fussy.

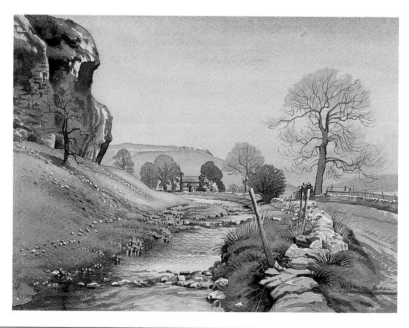

△ *Wild Orchids in Wolfscotedale, Derbyshire*
15 × 11in (38 × 28cm)
Rare flowers like these attract particular attention these days. They are rampant towards the end of May, vying for attention with the golden glory of the gorse blossom on these limestone slopes. Such proud carmine blooms parade here in their thousands.

In order to concentrate attention on the sunny bank in the foreground, I emphasized the blueness of the more distant recesses of the dale. The orchids and their blade-like leaves were protected with

masking medium before I washed greens, yellows and browns over the steep bank. Such detailed treatment of plants would be impossible without masking.

The floret clusters themselves were treated with combinations of cobalt violet, alizarin crimson and cobalt blue. In common with other less rare wild flowers, they mark a specific period in my countryside calendar. Flowers tell you what time of the year it is and are therefore very useful to the artist in providing an accurate setting for other seasonal country activities.

◁ *Marsh Marigolds below Kilnsey Crag, Wharfedale*
15 × 11in (38 × 28cm)
This is typical of limestone country, the April sun gleaming on silvered stones and walls and the famous overhanging crag. The marigolds fringed the beck like a golden necklace and I couldn't resist their plump blossoms which, as children, we used to call 'mayblobs'.

When painting it I kept the treatment very simple and the colours restrained, in keeping with the gentleness of spring. This helped to add emphasis to the richness of the yellows.

△ *Spring Flowers, Pembrokeshire Coast, Wales*
22 × 15in (56 × 38cm)

In spring and early summer, coastal paths all round the British Isles are bordered by clumps of varied and colourful flowers like those here. This adds exhilaratingly to the pleasures of a clifftop walk.

This June morning was hazy and already hot. To indicate this I painted the sky wet-in-wet, the clouds in warm grey, so that all the edges were hazy and soft. Even the sparkle on the sea was treated with a muted drybrush effect.

The foreground cluster of vegetation involved a great deal of careful drawing with masking medium, to describe the individual flowers and plants. Here I made the fundamental error that rather spoiled this painting. Conscious that the haze was thick enough to veil even the brightest colours I tended, after removing the masking medium in the final stages, to cover the whole of the clusters of leaves and fronds with simple washes. This has subdued the lively variety of greens and produced a rather too uniform effect, plus a reduction of the vitality of the tangle of growth. I could have produced a much more satisfying and sunnier effect had I treated each cluster separately, enabling me to leave delicate edges of untouched paper which would have given a wider range of tones and thus a more lively and airy effect. Unfortunately not all paintings satisfy the high hopes with which we begin them.

△ *Mayblossom, Bradbourne Mill Farm, Derbyshire*
22 × 15in (56 × 38cm)

Early summer and the tender muted greens not yet hardened into high summer: the English countryside, some would say, at its very best. The yellows of buttercups and fields of rape just coming into flower are escorting the winding road into the distance. The rich, orange-red tiles of the farm buildings' roofs, stained with lichen, glow in the soft sunshine.

The sky, as can easily be seen, was painted wet-in-wet as usual but the clouds were tinted with creamy yellow ochre instead of the clear water I might more normally use. This adds to the mellow quality of the colour scheme and was carried down over the distant hills to indicate the sun on them. The faint hazy blues used for the details on the hills ensured a satisfactory effect of depth.

I thoroughly enjoyed painting the varied warm tones of the roofs which also provided a suitably simple example of linear perspective for those who may not yet have mastered it. See how the roofs appear to taper slightly as they move away from you. Being well below eye-level the lines of the tops and bottoms of the roofs slope upwards gently towards the horizon. If you were to extend these lines with a ruler, whether receding towards the left or the right, they would eventually meet on the eye level which to all intents and purposes can be equated with the horizon. The farmhouse does not demonstrate this rule, of course, as it is face-on and not receding into the distance. Note how the warm colours of the buildings are reflected in the blue waters of the stream.

The creamy thorn blossom is only just in flower. When it is fully open it will cover the bushes in great plumes of snowy white.

I added the cattle to reinforce the centre of the composition and also for verisimilitude. You expect to see some activity around a farm and the cows being driven out into the field in the centre provide this. Note how simply they are painted. Animals in the distance should be suggested rather than painted in detail.

The pheasants were introduced to echo the colours of the tiled roofs, thus unobtrusively linking the foreground with the middle distance.

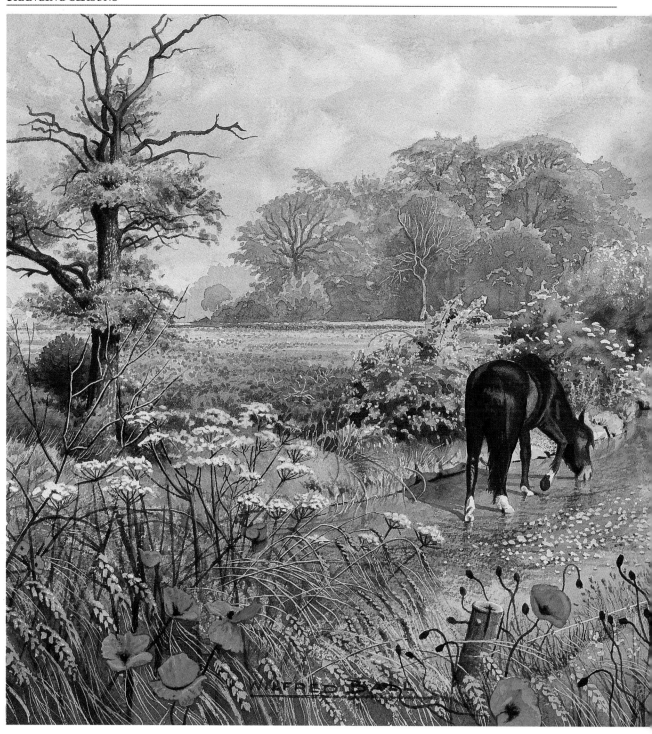

◁ *Poppies at Thulston, Derbyshire*
22 × 15in (56 × 38cm)

I have mentioned how I used to avoid high summer because of the monotonous strong greens. This painting was produced with the express intention of destroying that prejudice once and for all by introducing as many flowers and warm colours into it as I could reasonably expect to find in a single natural landscape. As you can see the result is both lively and colourful.

In order to get the maximum effect of recession the most distant trees were painted in pure blue washes. Between them and the foreground poppies is an infinity. The stream was painted wet-in-wet after the dry pebbles and the horse's fetlocks had been protected with masking medium. Cow parsley and other details in the foreground were similarly protected, as were the wild roses and elderflowers on the bushes behind the horse. This enabled me to take a large wash brush and put broad washes of pale colour over the whole of the rest of the foreground, the blue-green fields of unripened rape on the left and the barley on the right. Notice how much redder the poppies look against the complementary colour of the rape than they do against the warmer colour of the barley.

I needed to put the horse in because the centre looked the weakest part of the painting without it. Burnt umber was used for its sunlit flanks, and I then touched blue into this in the places where its glossy coat was reflecting the sky, particularly on the tail and its polished rump. The powerful darks were painted in using the darkest mixture I ever use, ultramarine and alizarin crimson. On top of the original wash of umber this looks really black. While on the subject of colours, note the bluish reflections in the crimson of the poppies on the right. Surrounded by the ochre of the barley the poppies on the left are much nearer to cadmium red.

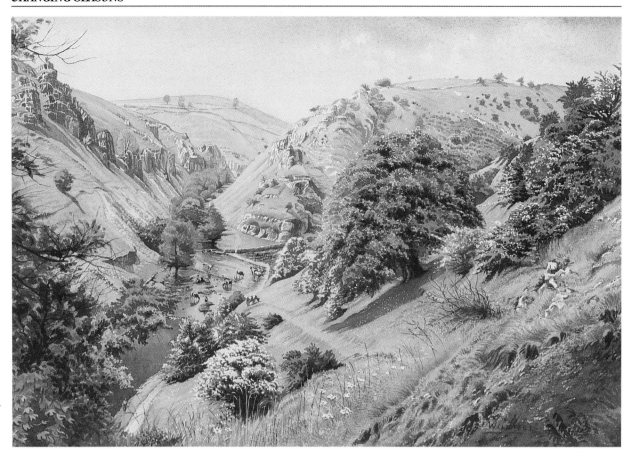

△ *Blossom time in Wolfscotedale, Derbyshire*
22 × 15in (56 × 38cm)

Not as well known as Dovedale but no less beautiful, Wolfscotedale carries the River Dove down into its more famous neighbour. Early in June the thickets of thorn are a snowy delight.

I began by painting the pale blue of the sky down over the most distant hillside. While the colour was drying I wrapped a finger in an old handkerchief and dabbed off small patches of pigment to suggest the soft, faint cloud shapes.

Because the subject was made up almost entirely of blues and greens I had to look carefully for warmer colours to add a little variety. The patch of rich red earth on the right was a godsend and so were the warm greys of the screes on the left of the river and the other tints on the right bank.

The cattle in the stream helped to reinforce the centre of interest, which might not have been very effective without them. However, if I am completely honest I must admit that I put them in chiefly because they were actually there.

▷ *Summer in Parwich, Derbyshire*
22 × 15in (56 × 38cm)

This is the kind of country cottage subject which delighted Victorian watercolourists. Roses round the door, blossom and banks of sunlit cow parsley edging the lane. The latter was deserted at the time but I realized the composition required some figures or animals as a focus. To pursue further the nineteenth-century analogy I decided they should tell a little story. With their love of literary titles a Victorian artist might well have called this painting *Does it bite?*

I keep folders of drawings and photographs of figures and animals for use in such circumstances.

Note how the horizontal shadows across the lane help to stabilize the composition. See also how the frieze of blue-green trees in the distance seems to push forward the yellower greens of the foreground vegetation. The blue reflection of the sky on the shiny leaves in the dense shadow on the left provides a valuable counterpoint to the sunny tints around it.

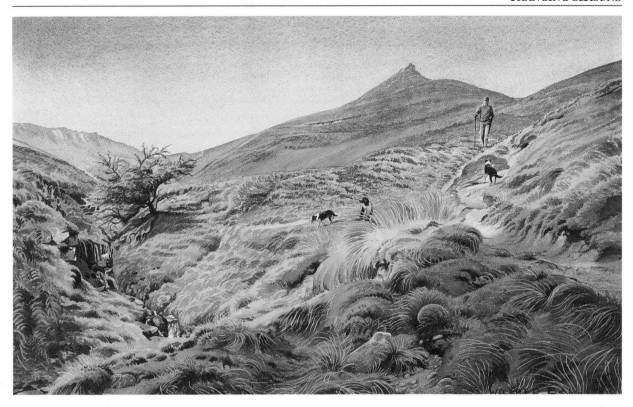

△ *Heather below Ringing Roger, Kinder Scout*
22 × 15in (56 × 38cm)

Heather is a rare delight on the high moorlands in August and September. During that time it changes in colour from a pale lavender, through lilac to a rich purple when it is in full flower, after which it turns redder and browner before it dies off altogether in October. This painting demonstrates these variations in colour, though here they are partly due to atmospheric perspective. Because of the blue haze through which we see it, the distant heather appears more purple than it would if we were close to it, while the patches of nearer heather have turned pinker under the warm sun and the slightly higher temperatures below. The advantages of a good strong shadow across the foreground are quite obvious here, in such a loose composition which lacks strong linear forms to tie it together. The figure and dogs were introduced to give a focus.

AUTUMNAL WOODLAND

October brings complete transformation in the appearance of the natural landscape. Trees take the place of flowers as the gayest part of the scene. From russet to rust, from gold to flame, they glow against the misty acres. New England is particularly well known for its vibrant colours at this time of year, and provides limitless opportunity and inspiration for the region's artists.

△ *Seathwaite Bridge, Dunnerdale, Cumbria*
15 × 11in (38 × 28cm)
Little more than a brush drawing, this was painted many years ago when my style was much simpler and looser. After protecting the silver birch trunks near the centre and leaving dry paper for the walls and road, I dampened the rest and painted it while wet or quite damp. A few darker touches were put in when almost dry to clarify the shapes of some of the more interesting trees and their trunks.

I think the simplicity of the treatment suits the subject admirably.

▷ *Mist in the Via Gellia, Derbyshire*
15 × 11in (38 × 28cm)
A gentle colour scheme of gold and grey amply illustrates this phenomenon which is so common in autumn.

After wetting the whole of the background I mixed a cool silver-grey and touched in the tops of the trees showing above the clammy clouds of mist which were obliterating most of the trees in the depths of the valley. A slightly warmer grey was used for the clouds in the sky and the bright yellow was put in with touches of pale cadmium orange. No attempt was made to clarify the skyline which merged imperceptibly with the sky. The birch leaves and dead weeds in the foreground together with the scarlet hawthorn berries look even richer in colour because of the contrast with the cool colours of the mist.

△ *Autumn Evening, Netherdale Farm, Monsal Dale, Derbyshire 22 × 15in (56 × 38cm)*

In striking contrast of light and shade the evening sun gleamed on the limestone tors above the far sunlit slopes of the dale. It silvered a small stretch of the river on the left, while casting a creeping shadow across the foot of the dale. In another ten minutes the farmhouse, too, would be swallowed up in the dimness. Never was I more grateful for my camera.

The sky was painted wet-in-wet with warm colours but I clarified the sunlit edges of the cloud on the left when it was dry. Note also how I darkened the sky on the left to emphasize the sunlit slopes. The trees were painted in with broad washes of warm colour and the shadowed riverbanks were covered with one simple wash. The sunlit wall in front of the farmhouse was left as untouched white paper to emphasize the bright sunlight on the stone in this focal area.

Some weeds in the centre were standing high enough above the shadow to be bathed in golden light and I masked them before painting the river. Here, as I have shown in earlier paintings the brilliance of the reflected colour is emphasized by the surrounding gloom. The silvery streak of light on the surface was scratched in last with a single stroke of a sharp knife. The lack of figures and animals adds to the feeling of tranquillity.

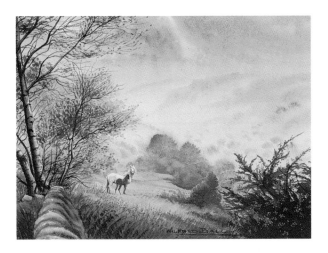

RURAL ACTIVITIES

The countryside is not just an attraction for visitors, it is also a workplace. For most of us the activities of farmers, shepherds and their livestock add to the general attraction of the scene. I view with keen interest the lambing, dipping and shearing stages of the sheep-farming year on the fells where I tend to do most of my painting. Figures engaged in haymaking, fencing, drystone-walling, repairing buildings, ditching and attending to livestock are readymade focuses of interest in many of my works. Here are a few examples.

△ *Springtime at Stonethwaite Farm, Borrowdale*
22 × 15in (56 × 38cm)
Lambing time draws people into the country more than any other activity. The dancing and prancing of new lambs provides entertainment. In this lovely little Lakeland hamlet the tender new growth and the newly delivered lambs combined to epitomize a Cumbrian spring.

I was keen to capture this effect, so I kept all the greens light and sunny. On the most distant fell I painted in the delicate green of the new foliage with one overall wash before painting the warm grey wash which covered the rest of the fell around and amongst the tree shapes to produce the effect I wanted in the simplest possible way. The nearer, sunnier trees on the slopes immediately above the farm were painted with pure cadmium yellow to focus attention on their glowing backlit colour. The translucence of the large tree was a slightly more difficult effect to achieve. My solution was to strengthen the dark, silhouetted trunks and branches in an attempt to emphasize the sunlit foliage in contrast.

Amidst all the colour the white Lakeland farm easily holds its own as the focus of the composition.

△ *'Mucky Duck' Farm, near Sedbergh*
22 × 15in (56 × 38cm)

The muddy tracks around this farm with its fine duckpond indicate quite clearly the reason for its local nickname. It is a very detailed and confused scene, simplified by the top half being high-key and the foreground in low-key tones. In the light area a few shadows provide variety and detail. The small patches of sunlight on the bank in front and the white fowls break up that otherwise densely shadowed area. This and the dark tree on the left prevent the composition from dividing into two distinct halves, and the shadow lying across the bottom gives an immediate sense of weight and stability to the composition.

Note the interesting colour change in the lane. Under the overhanging trees it has remained wet and the slick blue surface reflects the sky. Where it has dried out in the sun at the far end it basks in earthy ochres and browns in the full sunlight. This is a fortunate disposition of light and colour as it draws the eye nicely into the picture.

Although this is a 'busy' painting because of the amount of interesting detail – note the old tractor and wooden farm cart axle-deep in the pond – there was no farmyard activity to be seen. The only movement was from the white ducks on the far side of the water and they were so small as to be inconspicuous. I decided that some fowls would provide this sense of activity, as well as some much-needed richness of colour among the cold tones of the foreground. Having placed them very carefully I finally put in the one standing on the tumbledown wall on the right. Situated in front of the lightest area of the background it became just the eye-grabbing shape the picture needed for its focus.

Complexity of detail poses many problems to the painter. My ways of tackling the complexity inherent in this painting should be of some assistance to you when you face similar difficulties. The detail needs to be subordinated to a simple overall design which can harness it to the basic pattern.

△ *Coming Down off Kinder Scout in Summer, Edale*
22 × 15in (56 × 38cm)

The sheep farmer fetches his flocks down from the fells several times a year: for lambing, and much later to separate the ewes from the full-grown lambs when they have matured, for dipping and for dosing against the many ailments with which sheep can be afflicted. Here is a full scale 'gather', as can be seen by the number of men and dogs involved.

My eye was first caught by the marvellous colour of the heather on the breast of the slope newly lit by the summer sun. The subtly misted greys of the cool background served to reinforce the brilliance of this rich hue. On the left the thick mist, into whose blue depths the main bulk of Kinder Scout has completely disappeared, is not the least effective of such contrasts by any means. To produce the heather colours I used combinations of cobalt violet, cobalt blue and alizarin crimson.

▷ *Drystone-Walling in Wensleydale, Yorkshire*
15 × 11in (38 × 28cm)

We were walking over from Summer Lodge Moor in Swaledale to Askrigg in Wensleydale – real James Herriot country – when we came upon this trio of farmworkers ignoring a cold, blustery wind as they followed their laborious craft.

The stormy sky was painted wet-in-wet and some interesting accidental edges were produced by adding some stronger grey pigment into the lower right-hand area of the two irregular dark clouds before the first washes had dried. By tilting the paper slightly, the stronger pigment was persuaded to pool towards the right, resulting in the uncontrolled accents and edges. This was in keeping with the stormy mood of the painting. The window of cobalt blue on the right was used to clarify the edge of the white cloud.

The figures were developed from photographs taken at the time.

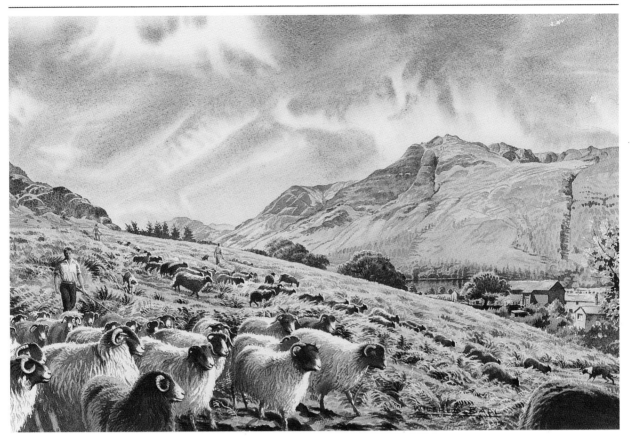

△ Sheep Gather in Buttermere 22 × 15in (56 × 38cm)
A very similar subject to the previous one, this flock is being driven through summer bracken down to the village below the High Stile range.

Apart from the formal information concerning animal husbandry which I picked up while watching this noisy and dusty drive, the most interesting part of the painting for the student of watercolour will be the sky. Having decided it should be a vigorous cloudscape, in keeping with the subject, I painted it wet-in-wet with quick, lively strokes of a wash brush copiously charged with pure cobalt blue. This produced a sweeping sky, swirling with sunlit summer cloud and in complete sympathy with what was happening below.

△ *Morning Cast, Kirkby Lonsdale*
11 × 15in (28 × 38cm)

You will see anglers on most rivers for a good many months in the year. I use them frequently to add a touch of extra interest. This figure is actually from a photograph I took near Applecross on the west coast of Scotland. It is very important to catch the figure at a significant moment like this so as to maximize its value to the painting.

The edges of the figure, the rod and line, the sunlit branches, the yellow leaves and the stones in the river were all protected by masking medium before I began. To keep the colour scheme fairly restful I kept the blues quite warm, so as not to be too confrontational with the yellows and rusts, which are the natural contrasts to blues. First I washed pale blue over the sky and the stream, dropping some yellow into it in the foliage areas

while it was still damp. When this had dried I mixed darker blue-greys for the shadow under the trees on the far bank and the reflections in the water. The mixture on the right had a little green in it.

Next I painted the green grass on the bank and the browns and rusts of the shoals of dead leaves between the sunlit stones. The tree was painted with pale ochres and brownish greens which were strengthened with a powerful grey on the shadowy side and under the branches.

Having rubbed off the medium I was able to tint in the uncovered parts with pale colours, though I was careful to leave untouched paper for sunlit highlights on the angler, the branches and the stones.

The result is a gentle, tranquil scene, in keeping with the contemplative nature of fishing.

EXPRESSIVE USE OF HEIGHTENED COLOUR

The single most expressive element in painting is colour. By making a colour more intense than it appears in nature, therefore, it is possible to create or emphasize a certain mood in the painting. This is part of the necessary combination of selection and emphasis which is the artistic process.

Traditional landscape painters, whose aim will be to paint real landscapes with a recognizable sense of place, will have to beware that they do not exaggerate colours too much and destroy the realism. In my own case I tend to extend the use of the particular hue I am exaggerating throughout the whole harmonious colour scheme. It becomes visibly a yellow painting or a blue painting as you will see from some of the examples which follow. Of course, as I am aiming to be true to the landscape at all times, I use heightened colour only rarely. Often, I must confess, it is just that I have fallen in love with a particular colour.

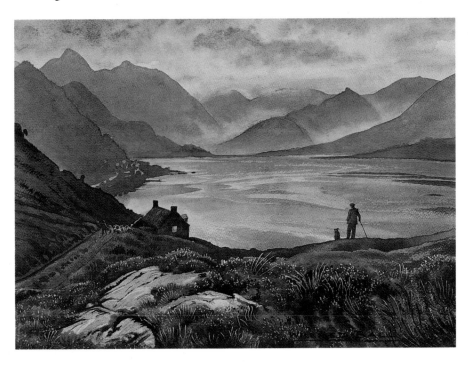

△ *Daybreak, Loch Duich 15 × 11in (38 × 28cm)*
Blue is a truly romantic colour and in combination with the noble purple of shadowed heather it produced a striking colour effect here. I was standing beside the old road above the Eilean Donan Castle when the sun came up and suffused the clouds in a rosy light which was also reflected in the waters of the loch.

The important element in this painting was the mixing of the basic blue. A pure blue would have reacted sharply against the warmth of the sky so I warmed the blue mixture with a little crimson. This colour really was crucial to the appearance of the mountains which were virtual silhouettes standing in a foam of cold mist.

I did not paint the glow in the water until the sun had risen sufficiently to be well reflected in these gorgeous colours. Earlier the reflection had been just a faint tinge of crimson. Throughout the painting I was aware of heightening colours to achieve a romantic super-real effect.

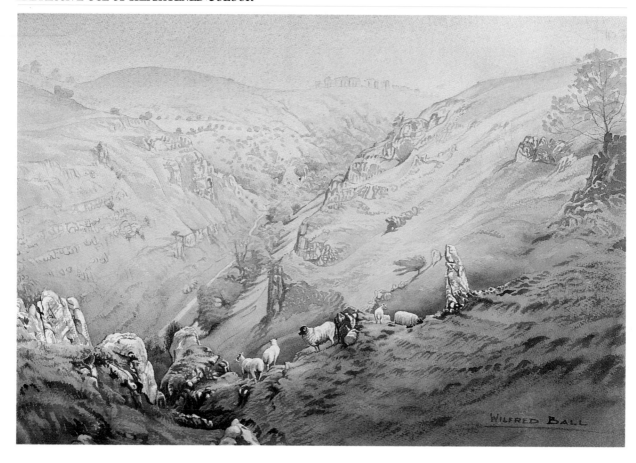

△ *Hazy Day in Wolfscotedale, Derbyshire 22 × 15in (56 × 38cm)*

For months before starting this subject I had been falling in love with cobalt blue. Increasingly the faint blue-greys in the distances in my paintings had become bluer and purer. The blue haze on this particular day created perfect conditions for me to achieve my ambition of using blue in a way that was aesthetically satisfying and at the same time romantically realistic.

The whole of the background was painted wet-in-wet, and diluted cobalt blue was brushed into the entire area, stronger in some places than others. While it was still wet I brushed in a little pale yellow ochre for the hazy light at top right. Then, using increasingly stronger yellows and yellow-greens, I suggested the sun glowing on the hazy grassy slopes in the middle distance. When these washes had dried I put in the distant hills in the most delicate of pale blues. With the exception of the subdued greens on the nearer trees all the rest of the detail was painted with very bluish greys, with special emphasis on the lovely blue shadow behind the two sunlit lambs in the centre of the foreground.

I felt really pleased with the result. The delicate blueness misting the whole of the valley seemed to me to be both aesthetically and atmospherically delightful.

The foreground could not have been more fortuitous in emphasizing this blueness. Orange is opposite blue on the colour circle and by the principle of simultaneous contrast orange will make colours near to it look bluish. Blue of course will look bluer in contrast. Here the lovely warm yellows of the lichens on the limestone crags and the sunlit grasses exaggerated the blueness in the background beautifully. It brought with it problems, of course. The foreground was almost all in yellows and greens, making a division of the picture surface which was quite stark. I solved this by washing blue over the entire foreground except the sunlit area on the left and the rest of the sheep.

Few paintings turn out exactly as one had hoped, but this one did.

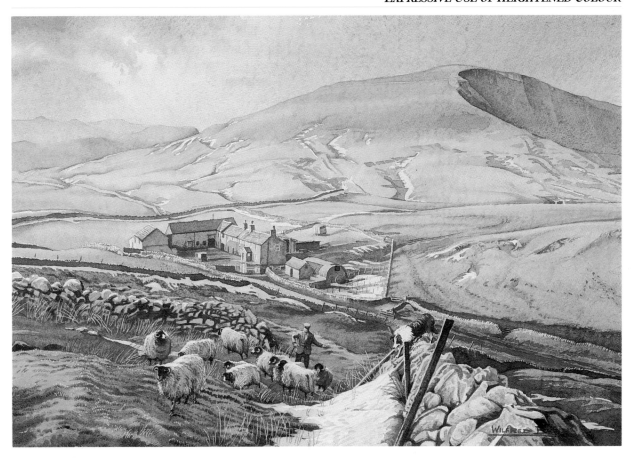

△ *Evening, Mam Tor from Winnats Head Farm, Derbyshire 22 × 15in (56 × 38cm)*

It had been a crisp, sunny winter's day. Now the sinking sun bathed everything in an even, golden light that seemed to leach the other colours from the landscape. Both reality and my own desire to paint a harmonious yellow composition combined happily. I hoped that my emphasis on colour harmony, the mellowness of the yellows and the horizontal composition would all combine to create that feeling of tranquillity which is so often a part of the going down of the day.

I painted the sky wet-in-wet, the cool blue away from the low sun being carefully selected to emphasize the yellowness of the rest. The warm

yellows were actually tints of cadmium orange. With the exception of the drifts of snow in the hollows, the entire landscape was then painted over with a wash of pale yellow ochre in order to capture the all-over mellow light. Under the warm blues and blue-greys I used for the detail throughout the picture this yellow ensured a subtle harmonization of the cooler detail. The dramatic appearance of Mam Tor, the 'shivering mountain' at top right with its landslip, was kept as unobtrusive as possible by treating it with the simplest of blue washes.

In spite of the activity in the foreground an air of calm quiet characterizes the atmosphere. I think the colour treatment is the chief contributor to that.

KINDER EDGE.

▽ *Calm Evening, Edale from Kinder Scout 22 × 15in (56 × 38cm)*

As in the previous painting, atmosphere is all. This scene captures a moment in time when all was still and peaceful. The feeling of great space adds to this, a feeling created by the simple treatment of the sky and distant ridge. At the time I was greatly affected by the endless sky and its comforting purity of unchanging warm colour.

This is one of those simple skies whose serenity is quite difficult to paint. I could not afford the slightest blemish in its resonant perfection.

Having wet it I painted a mixture of yellow ochre and cadmium red across the top with my largest wash brush, then continued the graduated wash by adding a little more of the red as I came down the paper. The wash was carried down over the distant hills which I later painted dry with virtually no detail, as they were gradually being obscured by the evening mist. Down in the dale this misty atmosphere was covering all but a few of the nearest trees.

As with the previous painting it is the harmony of colour which is mainly responsible for the air of tranquillity. Reds and pinks and reddish browns are to be found in almost every area and create a

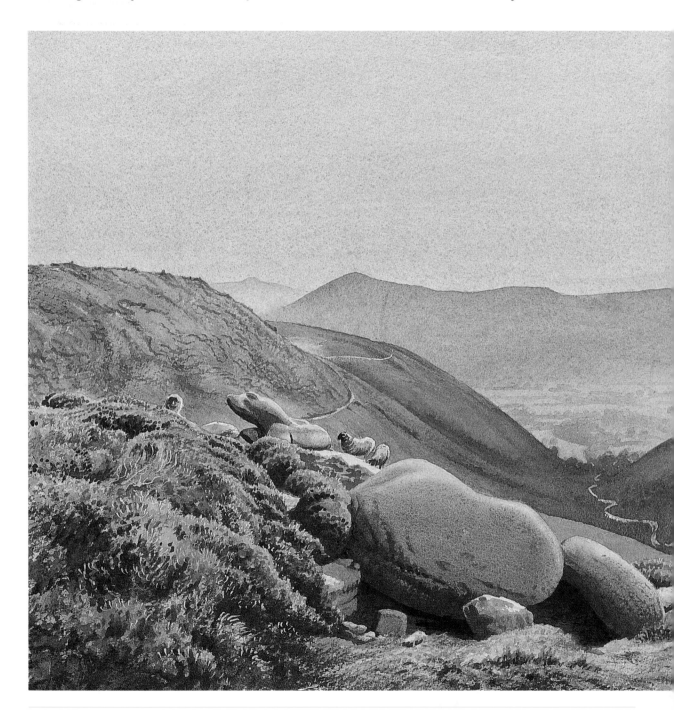

satisfying warm glow throughout. Because the foreground is of heather moorland a harmonious colour effect was achieved which could not have been possible if the foreground had been of green summer fields and trees, however much the warm light had suffused their colours. Are not these heather colours glorious in the evening sun?

The carefully placed sheep and sunlit rocks are important in their role of driving the middle distance away from the foreground. Reflecting the sky overhead, the gleaming stream in the depths of Grindsbrook Clough leads the eye away into Edale.

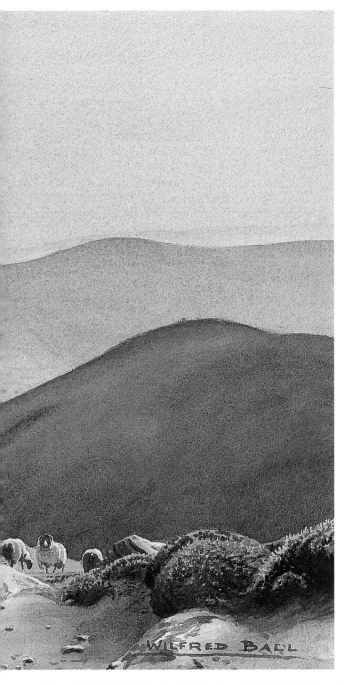

△ *Winter Track, Bradbourne 15 × 11in (38 × 28cm)*

I have mentioned earlier that I think gentle, simple skies are safer to paint than the gaudy colours one often sees in a really flamboyant sunset. Here is one occasion where I risked a full-blooded sunset sky. I felt that the misty woods and intervening trees would act as a screen, to subdue the effect without really disguising the brilliance of the colour.

The snow in these circumstances has to reflect the warm light from the sky while at the same time looking cold. I warmed the cobalt with crimson until I had produced a lavender mixture for the shadows on the snow, which looked just about right.

In order to reduce the impact of the bright sky it was important to get rid of a good deal of the cold colour in the foreground and replace it with warmer colours. The tangle of timber on the right of the path was put in for this purpose, as were the two pheasants. What, in my opinion, caps the composition is the melt-water in the ruts which reflects, jewel-like, the brilliant sky. This succeeds in disseminating areas of warm brilliance throughout the whole painting, to its great advantage. The final effect is one of richness of colour enhanced by the cool greys of winter.

9

DEMONSTRATIONS

I have chosen to describe in detail the production of three paintings which presented very different technical problems. The initial stage is shown in each case. This allows each work to be discussed in much more detail than the other paintings in this book, so that my normal procedures should be completely clarified by these examples.

DEMONSTRATION 1

Golden Evening, Edale from Derwent Edge 30 × 15in (76 × 38cm)

△ *Stage 1*

As we returned from Back Tor on a freezing winter evening the sun dropped below the level cloud to fill the far amphitheatre of Edale with golden light. This rich glow was a gift from heaven, but the real challenge was to suggest the crackle of ice underfoot.

The sky area was dampened, then covered with a wash of cadmium orange, except for the central glow where a horizontal streak of paper was left untinted. While these washes were still damp the darker cloud forms were brushed in using a warm, strong grey of cobalt mixed with burnt sienna. The dark flanks of Edale were painted in with the same grey, as was the long, table-like plateau of Kinder Scout on the right.

I used a stiff hoghair brush to wash out the rays of light radiating down into Edale. Finally a wash of orange covered the iced-over surface of the pool in the centre of the foreground, as well as a patch of frozen melt-water on the path. These warm colours were important in echoing the glowing sky among the chilly snow-coated hummocks of heather in the foreground.

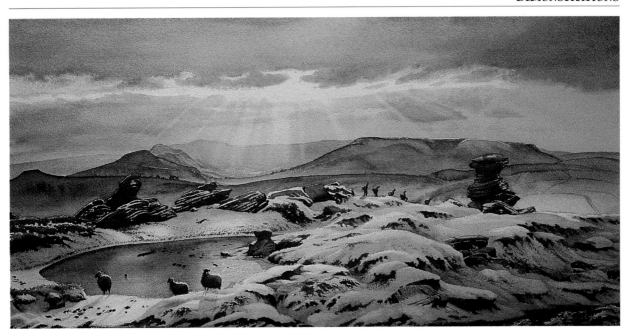

△ *Stage 2*

Only a few patches of snow in the foreground were touched by the sinking sun, so I was able to paint washes of blue, slightly greyed, over the whole of the foreground except for those patches which were left untouched, and the icy pool. The untouched areas were later tinted with pale yellow ochre to indicate the reflection of the warm evening light. So were the gleaming tops of the rocks on the Edge. Next I looked for the clumps of heather left uncovered by the afternoon thaw and tinted them in with burnt umber. The heavy shadows cast by the overhangs of the clumps of snow-covered heather were put in with strong greys, which were then used for the background rocks, the Salt Cellar on the right standing out particularly powerfully against the muted background. Next I put in the soft-edged cast shadows on the shimmering ice before emphasizing the tiny figures on the skyline and the foreground sheep. And, yes, I can feel the crunch of the ice under my feet along the path at the bottom.

DEMONSTRATION 2

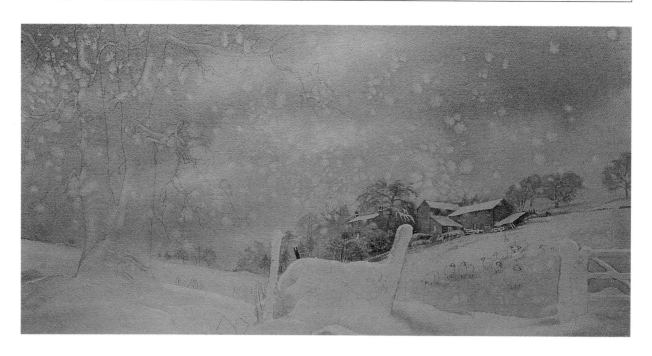

Heavy Snowfall at Calton Houses, Chatsworth
30 × 15in (76 × 38cm)

△ *Stage 1*

Huge snowflakes were drifting down so slowly that it seemed they might never reach the ground. The blanket of snow softly silenced this white world. Such was my challenge in tackling this subject.

After moistening the sky area I painted a cool grey over the whole area except for the peach-coloured 'windows' in the centre. I warmed the grey on the left with a little pale crimson. Crystals of sea salt were then sprinkled randomly onto the surface while it was slightly wetter than was the case with 'Backpackers on Malham Moor' (page 66). As a result it produced snowflakes that were larger and softer. The soft-edged grey trees behind the buildings were inserted while it was still damp. After it had dried I tinted the stone buildings with tones of raw umber. Next I washed a little pigment off the snow-covered roofs with a damp hoghair brush before putting in the overhangs and shadowed gables with stronger greys.

The background area being completed, I dampened the whole of the foreground before tinting the snow with varying strengths of pale blue-grey. When it had dried I put in darker tones behind the shape of the gate on the right. With a stiff brush I washed off colour to emphasize the snow on the branches and trunk of the tall tree on the left.

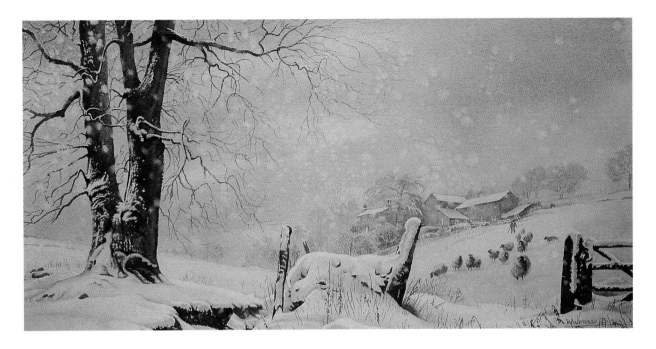

△ *Stage 2*

The strong foreground shapes were all put in with the same strong greys, except for the warm umbers used for the dead weeds and seedheads in the middle. Great care and skill were needed to leave accurate representations of the patches of wet snow clinging to the dark tree, the gate and the snow-crowned posts. The flock of sheep on the right were painted vaguely to emphasize the curtain of falling snow through which they were approaching. This effect, applying equally to the buildings and distant trees, was further emphasized by the strength of the dark accents in the foreground.

The technique of sprinkling salt crystals can never be completely controlled but here it has worked perfectly.

DEMONSTRATION 3

Early Morning Light, Thwaite, Swaledale
22 × 15in (56 × 38cm)

▽ *Stage 1*

Pulling aside the bedroom curtains early one October morning I was delighted to surprise the sun just climbing above the horizon. Tugging a few garments on top of our pyjamas my friend Rex Preston and I rushed outside with our cameras to catch the fleeting colours of daybreak.

Painting this, I covered the wet roofs, the weeds on the right and the tops of the stone walls with masking medium before starting on the sky, wet-in-wet. The glorious clouds were covered with varying tints of yellow ochre and cadmium orange strengthened with cadmium red. While this background was still damp I painted in the strong blue-grey, leaving flecks and tints of the yellow ochre showing through and outlining the broken edges of the warm clouds.

Apart from the water reflecting the sky, the whole of the foreground was submerged in shadow, so it was a simple matter to cover the area with a flat wash of blue-grey.

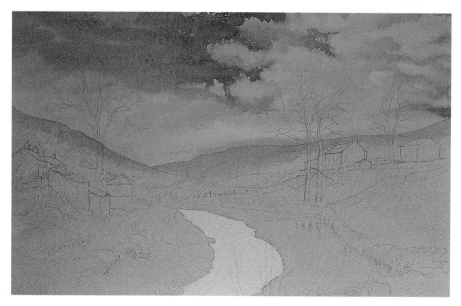

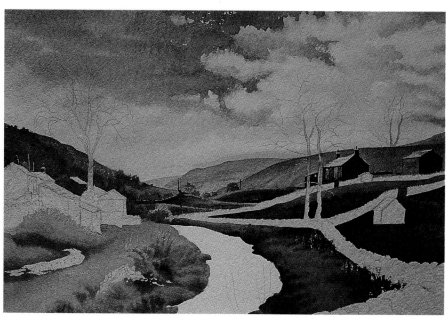

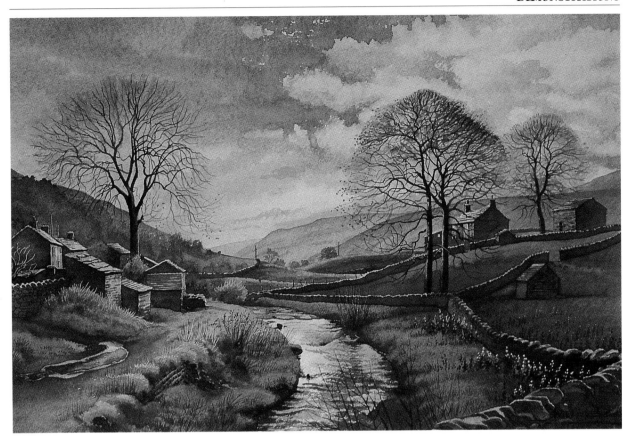

△ *Stage 3*
Having removed the masking medium I was able to tint the wet roofs and the tops of the walls reflecting the blue of the sky. Ochre was used to warm the sunnier walls of the buildings on the left, while the gable ends and chimneys emphasized the strength of

◁ *Stage 2*
The background hills were painted with washes of pale grey, increasing in strength as they came closer. On the left the nearest hill was treated quite powerfully but while the pigment was still wet a strong yellow ochre was introduced to give some modelling and to echo the sky colour. The same dark tones were used for the grassy areas to the right of the stream, which were almost totally overshadowed by the tall trees. On the left the vegetation was more open to the light and was painted in rich tones of warm green, yellow ochre and burnt umber. On the crest of the right-hand slope the two buildings were strongly delineated, as they were virtual silhouettes.

This left only the other buildings, the trees, the walls and the stream to be completed in the final stage.

the shadowed parts of these buildings. The very dark I used for the buildings was also used for the banks of the stream and the shadowed walls. Beside the wall on the right the lower parts of the weeds were darkened, while their sunlit tops were given a warm wash.

The tall trees on the right were burnished by the newborn sun behind them. I began by painting in this glowing autumn foliage with rich washes of cadmium orange and burnt sienna. The tree on the left had already lost its leaves, so when I painted its trunk and branches with the dark grey mixture they showed up more of their tracery than those on the right. In front, the stones atop the wall had dried out in the sun enough to show their natural warm colour, but those left in dense shadow remained wet and cold.

All that remained was the glistening stream. It was an example of two distinct reflections. Those from the warm clouds, in yellow and orange, were of liquid gold. The sky tones were reflected in jewelled blues that sparkled as the rising sun began to silver the rippling surface.

I felt the luckiest of men to have been there to see it.

10

GALLERY

Here is a collection of ten watercolours whose subjects need no explanation for my choosing them. Many are favourite subjects of mine which I've painted often and at different times of the year. Such scenes have inspired me to go back time and time again and have never failed me. Each has provided not just momentary but oft-repeated inspiration.

▽ *Clough Farm, Edale, Derbyshire*
30 × 15in (76 × 38cm)
I have walked round this farm at a distance and it looks interesting from all angles. Around the back, as here, it provides a detailed farmyard subject of the kind beloved of Victorian watercolourists. Although basically constructed of cool greys, blues and greens, there are enough drifts of rusty leaves, warm stone and sunlit grass to create an overwhelming sunny effect.

I introduced the fowls, all cheerful brown ones, for both colourful and nostalgic reasons. The bright accents provided by their combs and wattles make a valuable addition to the other warm colours.

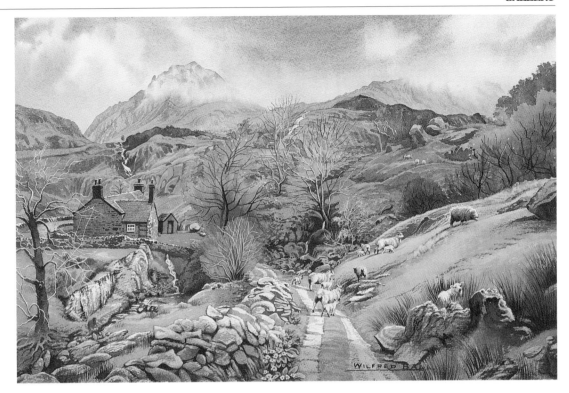

△ *Springtime in Snowdonia: Tryfan from Nant Ffrancon 22 × 15in (56 × 38cm)*

Whenever I return to Snowdonia I make a point of revisiting this spot with its magnificent view of the Falls of Ogwen below Tryfan. For once the low cloud veiled the mountain slopes without hiding the rocky summit. It made for a challenging piece of wet-in-wet technique. Into the wet background I brushed the cool grey shapes of the clouds and the mountains before touching a brush of clear water to the area of cloud in front of Tryfan and to the right. The blue was also painted in while the background was wet. Next I touched in some pale yellow to indicate the sunny slopes half seen through the wispy cloud. When this had dried I put in the detail on the mountains with a slightly darker grey.

This is a very complex landscape but I tackled it by a simple method. After protecting the waterfall with masking medium I painted the whole of the middle distance, above the farm, wet-in-wet with the greys I'd used for the detail on the distant mountains. While this was still wet I brushed in yellows and greens for the sunny and grassy areas, thus suggesting the topographical formations. Stronger details were put in when it had dried. This process helped to unify a very detailed and complex vista.

The lambs were a pointer to the season, but I added the primroses beside the track as an additional emphasis.

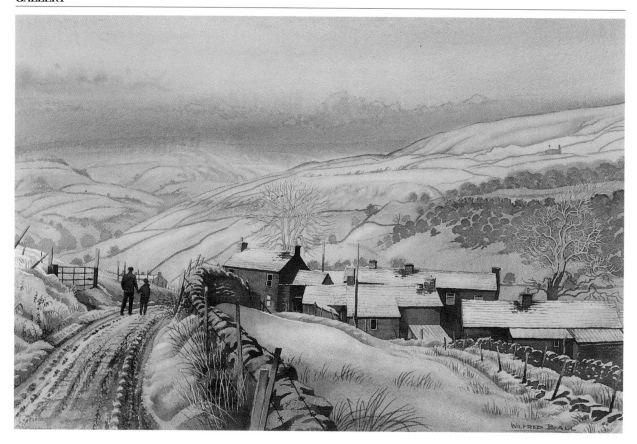

△ *Evening Light on Kisdon Hill, Swaledale*
22 × 15in (56 × 38cm)

This intense, rosy glow on the snowy hill only lasted for a few minutes, while the last red rays of the sinking sun blushed on it before falling below the horizon.

After wetting the background I washed a warm blue over the entire area and put in the warm grey of the cloud above the horizon, before dabbing pigment off the light tops of the clouds. These light areas plus the top of Kisdon Hill were warmed with tints of yellow and cadmium red. Stronger reds were used for the walls and other details on the rosy hilltop.

Except for the gilded trees and other details catching the light, I was able to cover the whole of the lower part of the composition with a wash of blue-grey shadow. The buildings, walls and figures were strengthened with varying shades of grey to complete the foreground. A little warm umber indicated the bare earth left uncovered on the lane before I used raw umber for the dead weeds along the wall.

One can only thank God for the good fortune to be there when such a remarkable phenomenon occurs.

▷ *The Langdale Pikes in the Afternoon Sun 22 × 15in (56 × 38cm)*

The sunlit, richly coloured foreground is glorious every October, but the eye is drawn inexorably along the narrow moorland road towards the pale but commanding shapes of the Pikes. This time of day is ideal for this composition because the long shadow of Pike O' Blisco stretches right across the valley and up the slopes of Lingmoor Fell, providing the perfect contrast of tone with the high key tints of the distant sunlit Pikes.

The sky was painted wet-in-wet, the creamy yellow of the clouds being touched into the pale cobalt blue while it was still quite wet. A little of the same pale yellow was used on the Pikes' sunlit slopes, but the warmer tones were of diluted raw sienna. These warm colours were emphasized by painting all the shadows and crevices in cobalt blue. In spite of the warm sunlight this blueness succeeds in keeping the Pikes very distant.

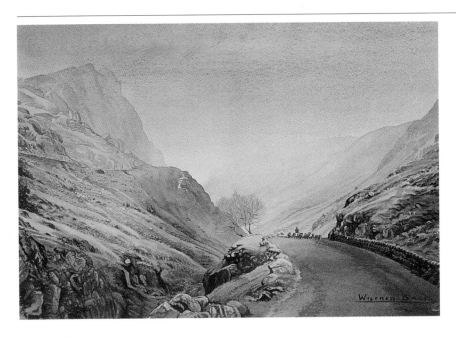

△ *Misty Morning: Honister Pass, Lake District*
22 × 15in (56 × 38cm)

A complete contrast of colour with the previous subject, but an equally noble view. I like it best in these conditions when the misted fells fade away and emphasize the sense of space. Painted wet-in-wet, the blue-grey graduated wash for the sky merges into the creamy light above the horizon, where the misty mountain to the right can barely be seen. I strengthened this misty grey slightly for each mountain towards the right, to indicate the gradual recession. High on the left, Honister Crag was painted next, the wash being allowed to fade into the distance low down on the right.

The effect of recession was maintained as I added increasingly stronger yellows and greens into the blued-off rocky slopes on the left. A watery sun nicely provides a sunlit tree and grassy bank on the bend of the road, where the flock of sheep emphasizes the focal point of the painting.

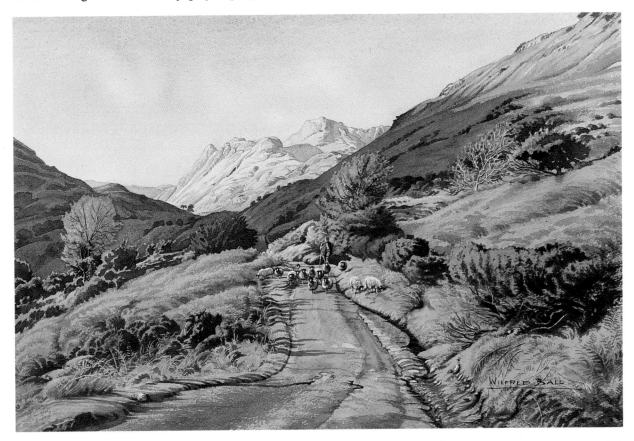

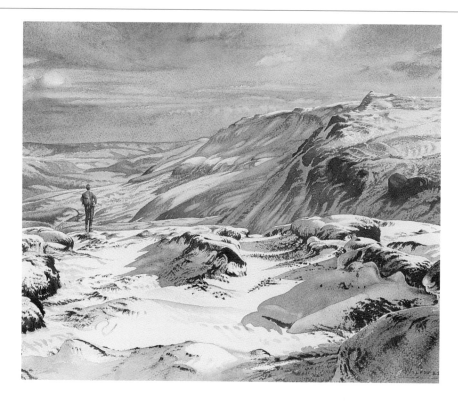

△ *Snow Shadows on Fairbrook Naze, Kinder Scout* *22 × 15in (56 × 38cm)*

Looking along Kinder Edge this North Derbyshire landscape compares for ruggedness with any part of the British Isles. Reflecting the intense blue of the afternoon sky the shadows were as precise and resonant as if they had been cut out of blue paper by Matisse.

The sky was painted wet-in-wet using a very warm grey for the heavy cloud collecting above the horizon and threatening more snow. While this was still wet I put in the graduated blue wash, which was allowed to merge with the edges of the cloud shapes. The individual light areas on the low cloud in the centre were fetched off by a finger wrapped in a clean cloth. Next the background was painted in with relatively strong blues and warm greys, which emphasized the brilliant white of the foreground.

The crisp blue shadows in the foreground had some pigment removed with a damp brush to indicate the reflected light inside them. Burnt umber was used for the few sunlit fragments of heather peeping through the snow. The darks of the peaty overhangs on the cushions of heather were painted in with the warm dark colour I mix from ultramarine and alizarin crimson.

I used the figure to give a sense of scale but his pose was kept deliberately in repose. However, the red of his clothing ensured a colourful focal point for the composition.

▷ *Rowan Tree and Heather below Seal Edge, Kinder Scout 15 × 20in (38 × 51cm)*

The mountain ash is particularly beautiful when it changes colour in autumn. Beside a tumbling cataract fringed by heather, this one was a fine specimen. You will have noticed how often I paint in the area around Kinder Scout. It is my favourite haunt in the north of my native county. A land of strange-shaped rocks and sparkling mountain streams, birch and rowan, great stretches of heather moorland below the looming battlements of this high plateau. And space!

After wetting the upper part I put in the clouds in weak, warm grey, then added the blue quickly so that the edges would be very fluffy. Note that I added a little cerulean to the cobalt on the extreme left. I lifted out some highlights with a finger wrapped in an old handkerchief, then tinted all the highlights with very pale yellow ochre. The same creamy yellow was used for the sunlit slopes of the great bowl to the left of Seal Edge. Finally I treated the detail and shadows with rather stronger greys and blues. As always, this part sets the atmosphere of the entire painting.

I painted the green foliage on the tree first, the upper part being tinted with a very weak yellowish green. When this had dried I carefully put in the delicate pinks and reds with cadmium strengthened lower down with a little alizarin.

The lovely textures of the sunlit bank of heather in the foreground owe a great deal to the preliminary use of masking medium.

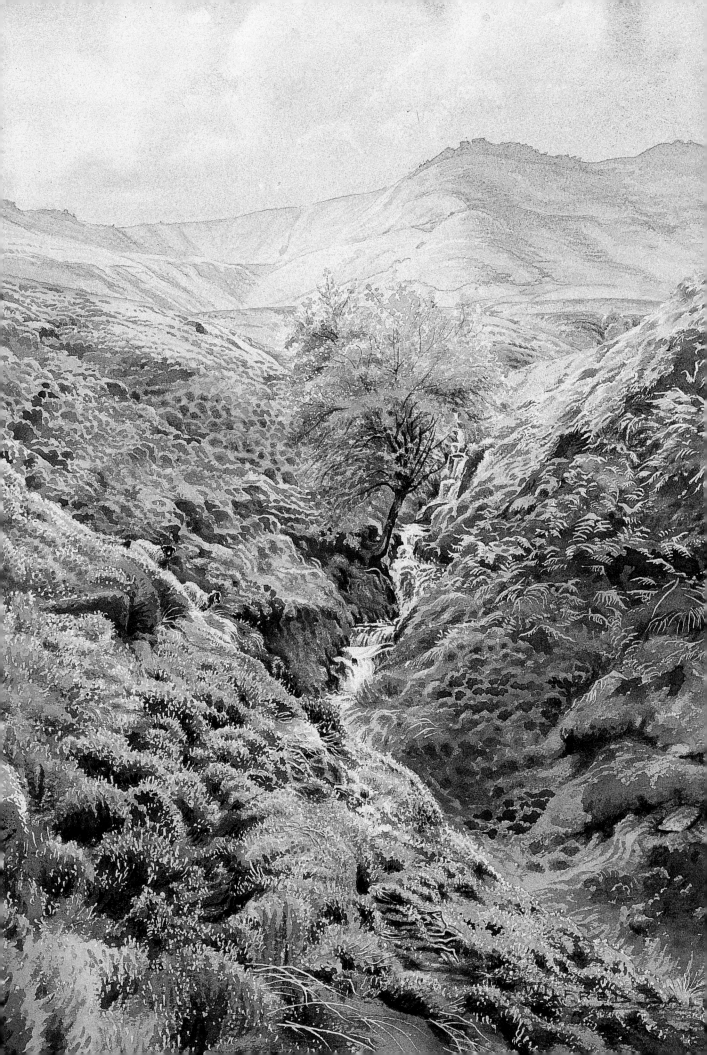

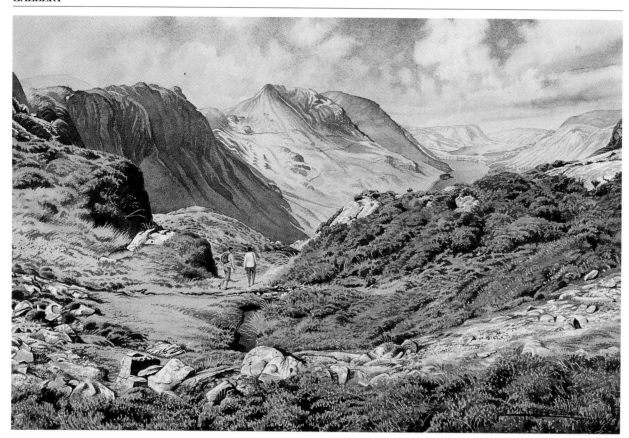

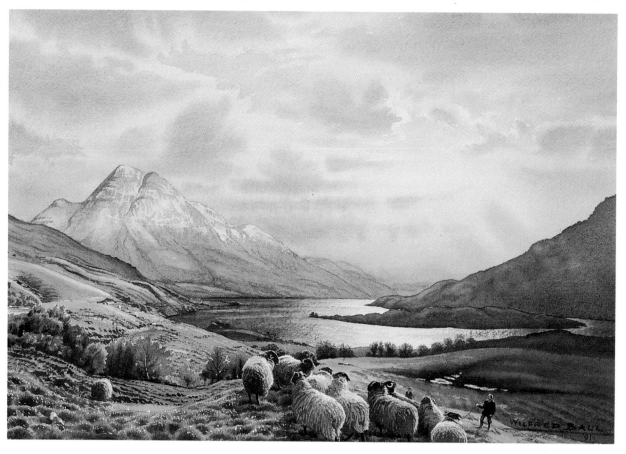

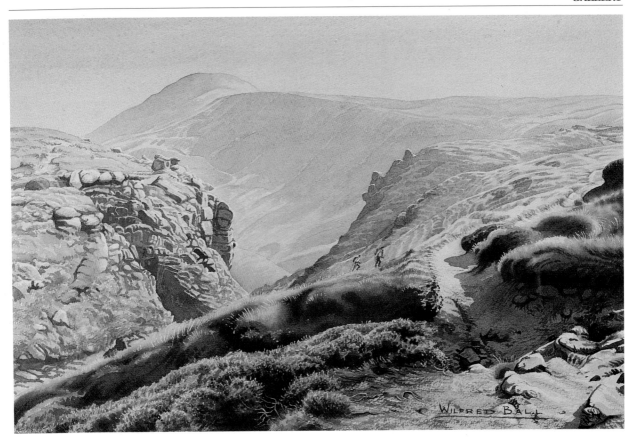

Above Buttermere in September 22 × 15in (56 × 38cm) (Above left)

Here is an almost perfect example of atmospheric perspective, the greys of the mountains becoming gradually paler and bluer as they recede. However, it introduces once again the problem of two distinct halves, the top being entirely in cold colours and the bottom in warm ones. I went some way towards countering this by widening the narrow channel in the centre which was reflecting the brilliant blue of the sky, thus ensuring a strong echo of cool colour among the richness of the heathers.

The cool shadows on the tumbled stones further assisted in this, as did the walkers' clothing.

Notice how the rich purples of August have disappeared, to be replaced by warmer, mellower reds, soon to fade into brown.

This view down Buttermere to Crummock Water is one of the loveliest in Lakeland.

Snow on Cul Beag, Inverpolly, Wester Ross 22 × 15in (56 × 38cm)

The first snow of the winter had fallen during the night and the mellow morning light emphasized the cold icing on the peak, surrounded as it was by the gold of autumn.

Except for the source of light on the right I washed pale yellow over the whole of the sky then

△ *Grindsbrook Knoll from Kinder Scout, Edale 22 × 15in (56 × 38cm)*

All the way round the great plateau of Kinder an edge path provides magnificent views. This is one of my favourites, particularly at this time of day. As in the group of paintings I described earlier, under the heading of 'Those blue remembered hills', early evening seems to paint distances in powder blue, in a romantic contrast to the warm colours of the sky. Here the blueness greatly emphasized the receding shapes, as blue always will.

The yellow sky was painted right down over these distant areas, the blues being superimposed after it had dried. Bathing everything in a creamy, evening glow, it produced a most evocatively poetic atmosphere.

Bright heather and strong shadows in the foreground ensured a powerful sense of recession.

put in the grey detail on the clouds while the sky was still wet. Pale cobalt was used for a few windows in the cloud, which clarified a number of edges, particularly near the source of light. Apart from the glistening silver highlights, the loch was painted yellow, reflecting the sky. When this was dry I used some fairly strong drybrush work on the darker water surfaces.

INDEX